POSTCARD HISTORY SERIES

The Mid Mon Valley

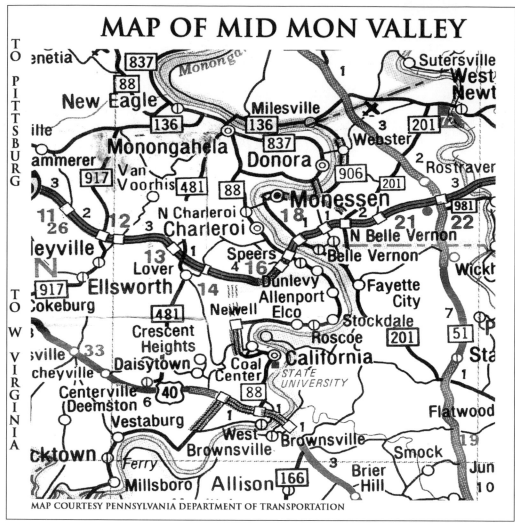

MAP OF MID MON VALLEY

The Mid Mon Valley is shown here in a Pennsylvania Department of Transportation map.

POSTCARD HISTORY SERIES

The Mid Mon Valley

Cassandra Vivian

ARCADIA

First published 2004

Published by Arcadia Publishing,
Charleston SC, Chicago IL, Portsmouth NH, San Francisco CA

Printed in Great Britain

Library of Congress Catalog Card Number: 2004102697

For all general information, contact Arcadia Publishing:
Telephone 843-853-2070
Fax 843-853-0044
E-mail sales@arcadiapublishing.com
For customer service and orders:
Toll-free 1-888-313-2665

Visit us on the Internet at www.arcadiapublishing.com

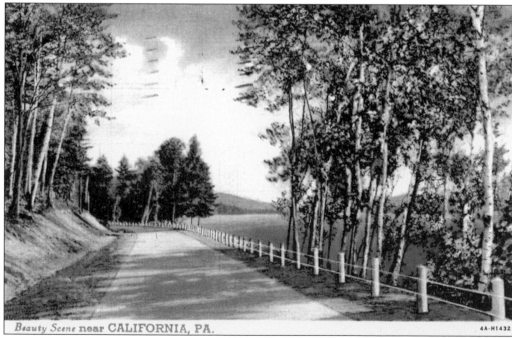

Beauty Scene near CALIFORNIA, PA. 4A-H1432

BEAUTY SCENE, 1942. The natural beauty of the Mid Mon Valley is shown here. The hills and valleys of the Monongahela provide beautiful scenery through all four seasons. The fabric of those scenes yielded trees for timber, meadows for farmland, strong stone for foundations, and coal for coke. (Published by C. T. Art Colortone, Chicago.)

CONTENTS

ACKNOWLEDGMENTS

No one can create a history of an area without walking in the shoes of those who have gone before them. I have researched this book using the early texts of the area and relied on the expertise of the various historical societies for their knowledge of the communities.

Special thanks go to the Brownsville Area Historical Society, BARC, the California Area Historical Society (CAHS), the Charleroi Area Historical Society, the Donora Historical Society, the Greater Monessen Historical Society, the Monongahela Area Historical Society (MAHS), and the Rostraver Historical Society.

Special thanks also go to the following individuals for use of their postcards: Glenn Howis of Donora, Charlene Lario of Charleroi, Bill Maurer of Belle Vernon, John Neill of Monongahela, Al Protin of Charleroi, and Ken Harhai of Houston, Texas (formerly of Monessen).

INTRODUCTION

The Monongahela River, a 128-mile powerhouse, is part of the gigantic Mississippi watershed that links more than half of the United States to the sea. Along the Mon, as it is known locally, are the railroads, roads, coal mines, steel mills, and related industries that in the early part of the 20th century made it the second most worked river in the world. It became known as the Arsenal for Democracy, as boats, trains, and trucks moved the raw materials and manufactured goods to national and international markets. By 1935, Mon River tonnage surpassed that of the Panama Canal. Local residents, who earned the statistical acclaim, divide the Mon into three regions: the Upper Mon, the Mid Mon, and the Lower Mon.

Founded in 1785 on the east bank of the river by Thomas Brown, Brownsville was the early gateway to the west. Pioneers trekked to Brownsville over the Nemacolin Path, later Burd's Road, and ultimately the National Road on their way to the new frontier. Traders and travelers turned in their wagons for flatboats and later keelboats, and that gave Brownsville and West Brownsville one of their major occupations: boatbuilding. Once river traffic was replaced by rail, Brownsville had one more era of glory—the coke and coal era, when the community became the center of transportation for the Pittsburgh Coal Seam. Today, Brownsville is rising from the ashes like a phoenix. California, a few miles north along the west bank of the river, was also a boatbuilding center. It was founded in 1849, and the first boatyard began in 1851. The two main industries of California were mining and education. The mines were the nearby Vesta No. 4 of the Vesta Coal Company, the Lilley, and the Crescent. More importantly, California had a small academy. It grew to become the most important industry in the community; the California Academy became a normal school, a teachers college, and finally California University of Pennsylvania. Between California and the next community stand a series of small, interesting hamlets beginning with Coal Center, an early-20th-century, west bank, riverfront community dominated by coal production. Across the river is Newell, tucked into the tightest horseshoe of the twisting river. Returning to the east bank, Elco, Roscoe, and Stockdale are next, and their history is linked to coal too. However, Allenport rose to fame via the steel mills, and although it has been downsized, it still has one of the few mills in operation on the river. Across the river on the east bank is Fayette City, where the last ferry ride ended in 1962.

By the time the river reaches Belle Vernon, again on the east bank, it has passed two other small towns: Dunlevy and Speers. It has also changed its complexion. There are more bridges. There are larger and more visible industries. Belle Vernon was laid out in 1812 and became a coal, glass, and boatbuilding center. As with the abundance of coal in the area, there was enough

gas and sand for the development of the glass industry. There are two Belle Vernons; the first is mostly on the river flood plain in Fayette County, and the second, North Belle Vernon, is located on the hilltop overlooking the river in Westmoreland County. Charleroi, back on the west bank, was named after a leading industrial city in Belgium, and many of its early citizens came from that community primarily to make glass in the new Charleroi factories. It was founded by the Charleroi Land Company in 1890 on property owned by Robert McKean. Charleroi was called the Magic City because it grew so fast, and glass was and still is its main industry. However, there were a few coal mines in the community and several factories that built coal mining equipment. Charleroi soon became the retail and entertainment center of the valley. Crossing the river yet again, Monessen became the industrial hub of the Mon Valley with steel and tin mills. Monessen was named for Essen, an industrial community in Germany. In its heyday, one of Monessen's 30 industrial sites employed 10,000 people from all over the valley. Those workers were mostly immigrants from southern and central Europe. Its heritage of ethnic churches and clubs still stands, but its industry is gone. Of all the communities along the Mon, Monessen suffered most at the hands of change and has struggled the longest and hardest to adapt to the new economy.

Donora, called Horseshoe Bottom in 1769, is another west bank industrial community. It was founded by the Union Improvement Company in 1899 on a site once called Columbia, and its largest industry was a steel mill with a zinc works. Donora bears the dubious distinction of being known for the Donora Smog, a zinc cloud that descended on the community, killing a number of people in 1948. It was the first known case of industrial pollution in the United States. Donora is also the sports center of the valley. It sired such favorite sons as Stan Musial of the St. Louis Cardinals, Ken Griffey of the Cincinnati Reds, and, when Donora and Monongahela merged their school districts, Joe Montana, arguably the best quarterback to play the game of football.

Webster crosses the river too. This small town was established by the Beazell family with the high hopes that it would become the center of life along the Mon. In the 1830s and 1840s, the citizens laid down plans to build a courthouse, but the grandeur never came. Webster did acquire a steamboat landing. The main occupations in Webster were boatbuilding and coal. The next community is Monongahela. The visible history of life at Monongahela is illustrated by a Native American mound from the Woodland period. The modern history of this west bank community began when Joseph Parkinson sold town lots in 1796. Boatbuilding and coal once again dominated life in the community. In fact, the Anton coal lamp was patented in Monongahela by the Anton Brothers, who had several factories in the town c. 1874. Another item invented in Monongahela was the foot-long hot dog. It could be found at Frankie's near Pigeon Creek.

The river, the landscape, and the architecture are not the only features that bind these communities. They were all part of the great industrial revolution that filled the streets with immigrants from the old world. Those immigrants strived for and got the American dream. What separates them is more complicated. The communities of the Mid Mon Valley fall into three counties: Fayette, Washington, and Westmoreland. Some say they should become their own unique county, because their problems are not shared by other communities. Others believe that the rivalry that began with the founding of each community is too difficult to overcome. The future will depend on how well they work together to save their valley and diversify their interests to fit into the 21st century.

One

BROWNSVILLE AND
WEST BROWNSVILLE

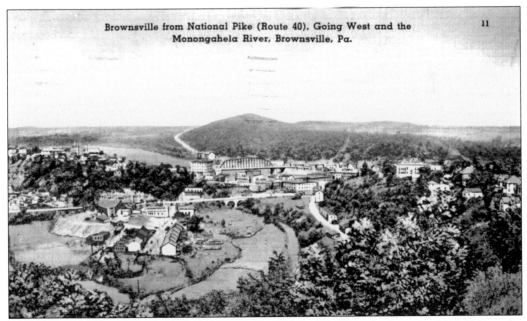

Brownsville from National Pike (Route 40), Going West and the
Monongahela River, Brownsville, Pa.

11

BROWNSVILLE, C. 1942. From the erection of a fort overlooking the Mon in the 1700s to the era of coke and coal in the 1900s, Brownsville has a long and glorious history. It holds many distinctions in transportation. (Published by Tichnor Brothers, Boston and Uniontown News Agency and Company.)

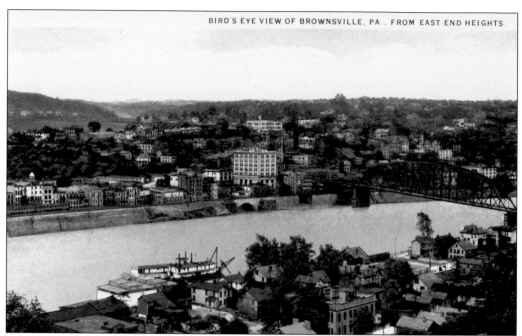

A BIRD'S-EYE VIEW. One look at the Mon in Brownsville helps one to understand why the river was designated as a public highway in 1782, before many roads existed, and why Brownsville became a boatbuilding center. (Published by Neff Novelty Company, Cumberland, Maryland.)

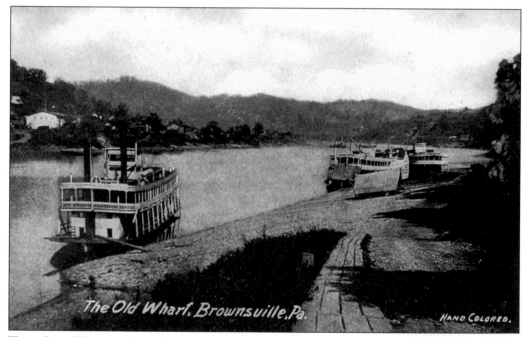

The Old Wharf, Brownsville, Pa.

HAND COLORED.

THE OLD WHARF. Several passenger packet companies grew in the mid-1800s. Almost all included stops in Brownsville. Probably the first was the Pittsburgh to Brownsville Packet Company in 1837. The Brownsville to Pittsburgh began in 1844. Thirty stops existed from Brownsville to Monongahela. (Published by Industrial News Company, Brownsville.)

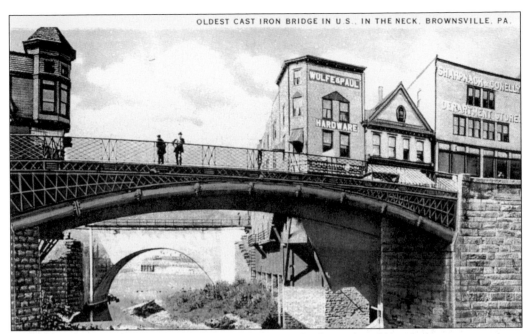

THE DUNLAP'S CREEK BRIDGE. Still operating, this bridge is the oldest single-span, cast-iron, deck-arch bridge in the United States. Designed by John Herbertson and supplied by the Snowdon Foundry, it was built under the auspices of the U.S. Army Corps of Engineers between 1836 and 1839. (Published by I. Robbins and Son, Pittsburgh.)

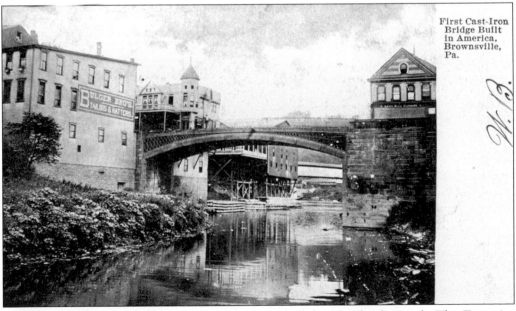

First Cast-Iron Bridge Built in America, Brownsville, Pa.

THE DUNLAP CREEK. Flatboats and keelboats were built here by the thousands. The *Enterprise*, the first steamship to go both down and up the Mississippi, was also constructed here. Captained by Henry Shreve, it carried munitions from the Pittsburgh Arsenal to Andrew Jackson in New Orleans. (Published by I. and M. Ottenheimer, Baltimore, Maryland.)

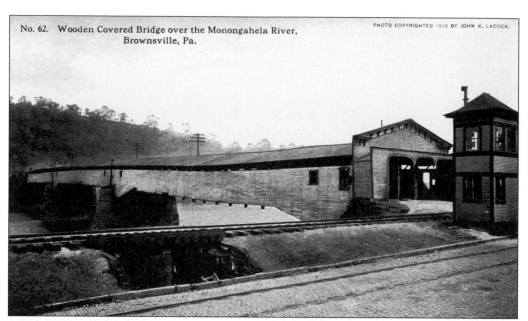

No. 62. Wooden Covered Bridge over the Monongahela River, Brownsville, Pa.

A COVERED BRIDGE. The first commercial crossing of the Monongahela at Redstone Old Fort (now Brownsville) was by ferry. It was replaced in March 1830 by this 600-foot wooden covered bridge, the first structure erected over the river. (Published by Leighton and Valentine Company, New York, New York.)

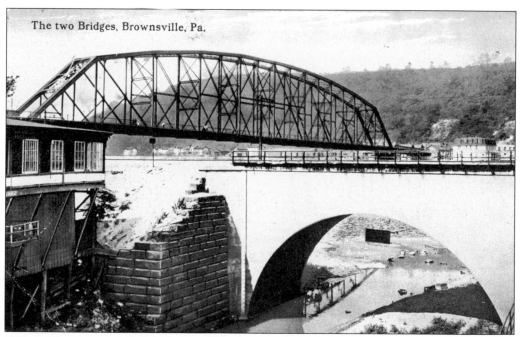

The two Bridges, Brownsville, Pa.

THE INTERCOUNTY BRIDGE, C. 1913. The covered bridge was condemned by the War Department in 1910 and replaced by the Intercounty Bridge in 1914. The 519-foot metal-truss bridge was refurbished in 1987. (Published by I Robbins and Son, Pittsburgh.)

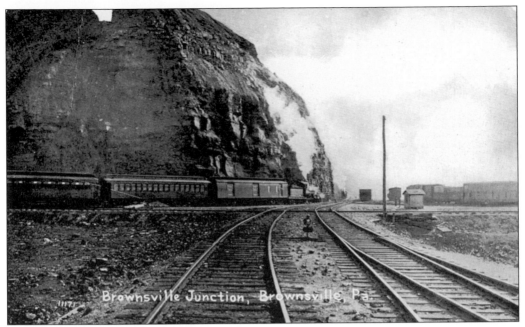

THE RAILROAD JUNCTION, 1907. The Monongahela Railroad ran for 27 miles along the east bank of the river when it was founded in 1900 by the Pennsy and the Pennsylvania & Lake Erie Railroad. Its purpose was to collect and deliver coal to steel mills in the area. It was still growing in 1984, bought by Conrail in 1993, and now owned by the Norfolksouthern.

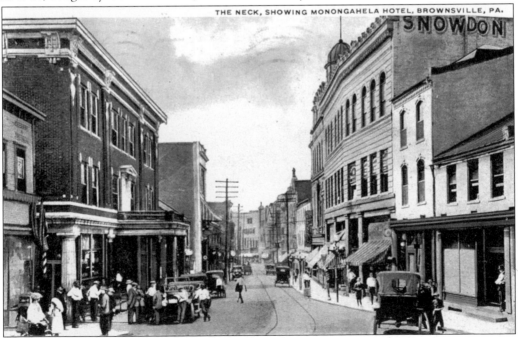

LOWER MARKET STREET, C. 1924. Called the Neck because of its precarious location along the cliff side, Brownsville's downtown held both the curved-front, white-brick Snowden building (right) and the pillared and red brick Monongahela Hotel (left). (Published by I. Robbins and Son, Pittsburgh.)

13

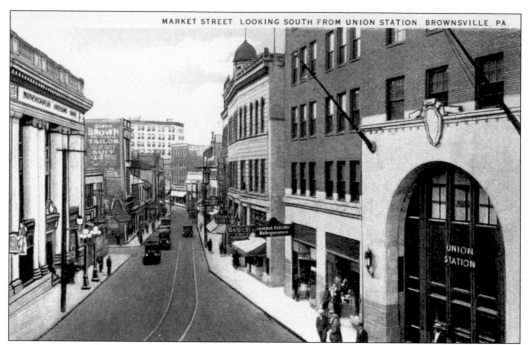

LOWER MARKET STREET. By the 1930s, Union Station (right) had been rebuilt and the Monongahela Hotel had moved. In 1925, the bank wanted to relocate along the Neck, so the hotel gave up its lot and rebuilt an unimposing 143-room facility next door. (Published by I. Robbins and Son, Pittsburgh.)

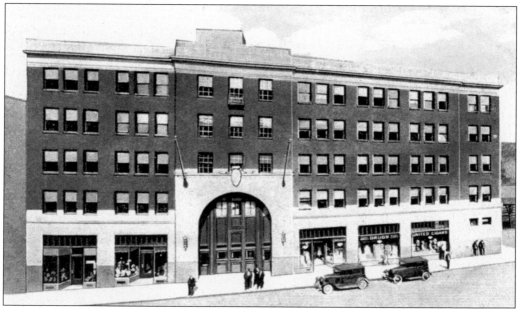

UNION STATION, 1932. The first Monongahela Railway Company building, built in 1903, was replaced by this five-story, brick, granite, and marble structure between 1927 and 1928. The building was contracted by H. K. Ferguson and designed by B. R. Magee. At its peak, a train left this station every 20 minutes. The last passenger train departed in 1959. (Published by I. Robbins and Son, Pittsburgh.)

THE MONONGAHELA NATIONAL BANK, 1931.
This was the third location of the Monongahela
National Bank. The building had 40-ton Indiana
granite pillars and served the community during
the coke and coal era of Brownsville. It still stands.
(Published by I. Robbins and Son, Pittsburgh.)

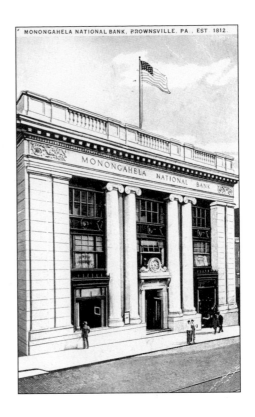

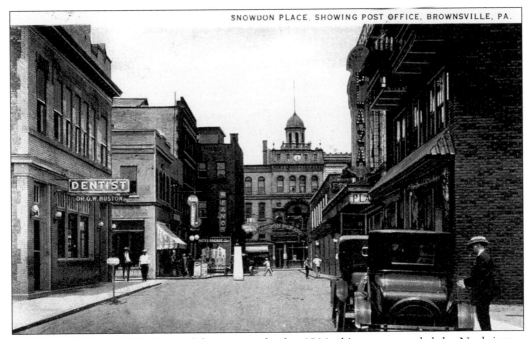

SNOWDEN PLACE, 1925. Created from swampland *c.* 1916, this area expanded the Neck into a
viable downtown. On the right is the Plaza Theater, which featured vaudeville, silent pictures,
and talkies. It was torn down in 2003. (Published by I. Robbins and Son, Pittsburgh.)

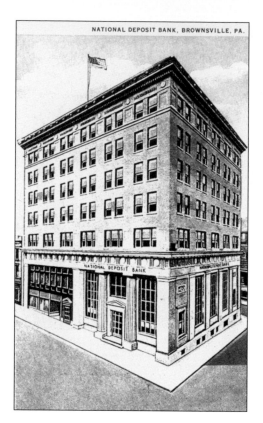

NATIONAL DEPOSIT BANK, BROWNSVILLE, PA.

THE NATIONAL DEPOSIT BANK. Built in 1923, this six-story building has a brick and stone façade and is the tallest structure in Brownsville. (Published by I. Robbins and Son, Pittsburgh.)

THE FLATIRON BUILDING. The first designated post office was in the Flemish-bond-style Flatiron Building, which got its name because it was shaped like an iron. It has been continuously open since then and has housed a library, a trolley stop, a tailor's shop, an insurance company, a dentist's office, and now a visitors' center and art gallery.

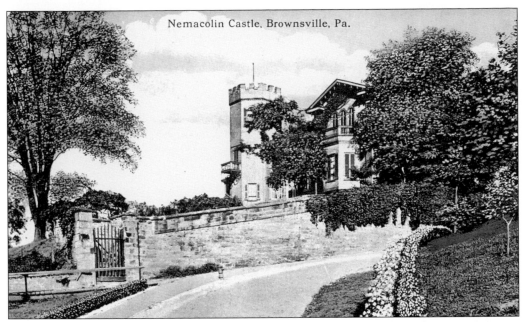

Nemacolin Castle, Brownsville, Pa.

NEMACOLIN CASTLE. Jacob Bowman built his trading post at old Fort Burd. As his family grew, the trading post was expanded and modified. Today, it is open to the public and operated by the Brownsville Historical Society. (Published by I. Robbins and Son, Pittsburgh.)

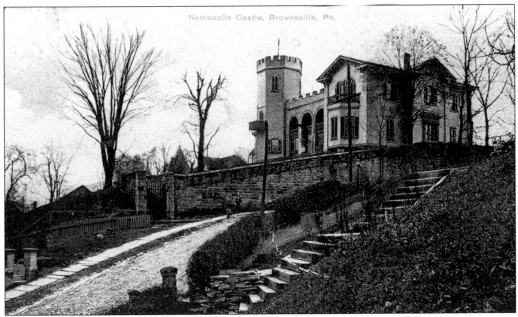

Nemacolin Castle, Brownsville, Pa.

NEMACOLIN CASTLE IN WINTER, C. 1909. The turret was added by one of Jacob Bowman's sons. Today, the castle has 22 rooms, including the trading post, marble fireplaces, chandeliers, and a balcony with a spectacular view of the Monongahela River. (Published by the Richie's Stores, Brownsville.)

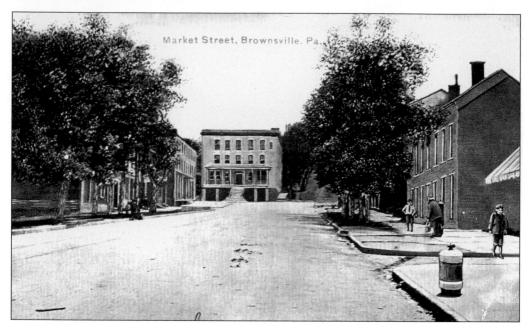

UPPER MARKET STREET. Market Street was chosen as the route of the National Road (Route 40). Lining both sides of the street are the original buildings. Shown in this *c.* 1911 image are the Girard Hotel (center) and the Brashear Tavern (left), which dates from the 1700s. (Published by L. G. Richie.)

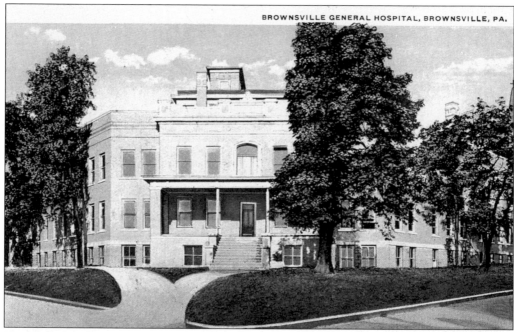

THE BROWNSVILLE GENERAL HOSPITAL. Erected in a W shape, the hospital was built in 1915. Across the street was the nurse's residence. It closed in the 1960s, when a new facility was built. (Published by I. Robbins and Son, Pittsburgh.)

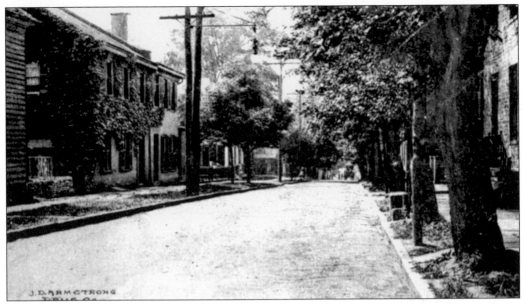

FRONT STREET. The original Nemacolin Path is the oldest commercial-residential district west of the Alleghenies. The buildings shown in this image include the Brownsville Academy and the Monongahela National Bank. (Published by J. D. Armstrong Drug Company, Brownsville.)

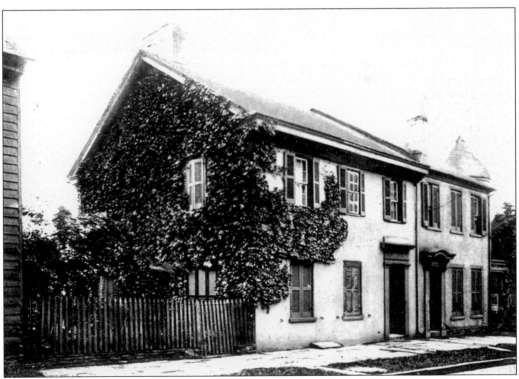

THE KNOX BIRTHPLACE, 1908. Philander Knox, the secretary of state under Pres. William Howard Taft, was born in this ivy-covered home on Front Street. It still stands as a private residence.

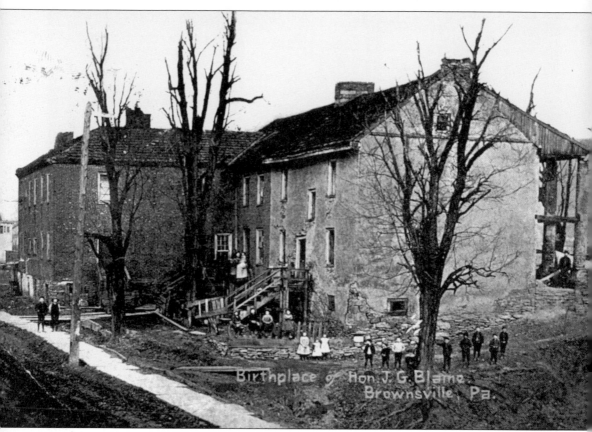

Birthplace of Hon J.G. Blaine
Brownsville, Pa.

THE JAMES G. BLAINE HOMESTEAD, 1907. Born here, James G. Blaine spent 46 years in politics. He was nominated speaker of the house in 1869, served as secretary of state under Benjamin Harrison, and ran for president in 1884.

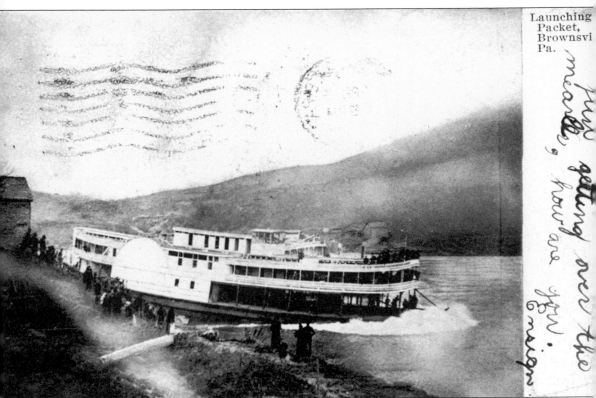

LAUNCHING A PACKET, C. 1908. From flatboats built in the 1770s to keelboats, sidewheelers, paddlewheelers, packets, and tows, Brownsville and West Brownsville built them all. In the yards of the Mon Valley the art of the shallow hull was developed, opening the rivers of the United States to navigation. In the 1800s, 60 percent of all the steamboats running on the Mississippi and western waters were built in the Mid Mon boat docks. In 1811, Daniel French was working at the mouth of Dunlap's Creek. In 1859, two boatyards existed at West Brownsville: Pringles, which began in 1829 and had built 546 boats by 1877, and Cock and Williams. Between them, 20 to 25 hulls were built yearly. Axton and Son built steamboats from 1885 to 1912.

BIG IKE, C. 1908. The paddlewheeler *Isaac M. Mason*, affectionately called Big Ike, was built by Andrew Axton and Sons in Brownsville in 1893 for the Mason packet line that ran from Belle Vernon to Morgantown. It burned at Cooks' Ferry on the Ohio on the morning of March 4, 1913. Other Brownsville and West Brownsville boats were the *Adams Jacobs* (1864) and the *Americus* (1853). Both were sternwheelers that were with General Grant on the Tennessee River during the Civil War. The *Cuba* ran on the Red River and the *Zephyr* on the Arkansas and Missouri Rivers. The *Illinois*, from the Pringle yards, was the largest sidewheeler built in Brownsville. The *Navigator* (1850) carried the casket of Pres. Zachary Taylor from the Monongahela Wharf in Pittsburgh to Louisville, Kentucky. (Published by Industrial News Company, Brownsville.)

Two

CALIFORNIA AND

COAL CENTER

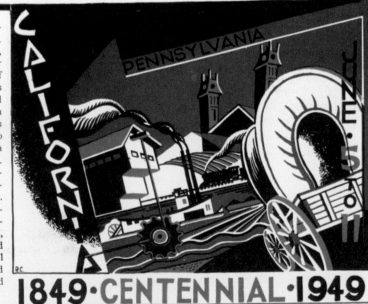

California, Washington County, Penna., is located in the steel, coal, and coke center of the world. One of the largest coal mines in the world, operated by Jones & Laughlin Steel Corporation, is located here. It is also the home of California State Teachers College. California will celebrate its 100th birthday June 5th to 11th. Talks by men of Industry, Labor and Education, Parades, Sports, Fireworks and a gigantic pageant will be features. You and your friends are invited to attend.

CALIFORNIA · PENNSYLVANIA · JUNE 5·11

1849·CENTENNIAL·1949

THE CALIFORNIA CENTENNIAL. California was named after the state of California because it was founded in 1849, the year of the gold rush. In 1767, before the birth of California, a meeting was held in the flatlands by concerned American Indians who were fearful of the incursion of Europeans. (Courtesy of CAHS.)

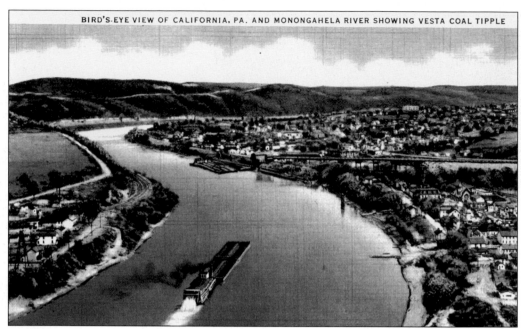

LOOKING SOUTH. Like California, most valley towns were founded on the flatlands of the river. Shown on the right is Coal Center, followed by the Vesta No. 4 tipple, and California. On the east bank of the river (left) is Newell.

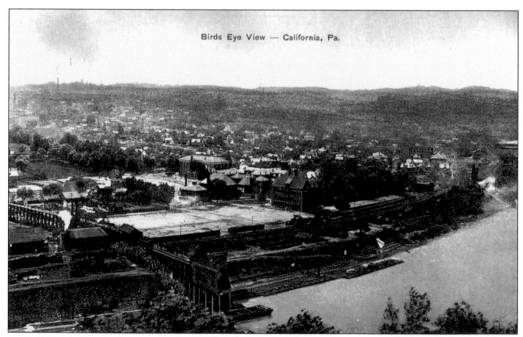

Birds Eye View — California, Pa.

A BIRD'S-EYE VIEW, C. 1910. Farther south, another tipple and early California University buildings were located along the river. (Published by California Pharmacy.)

THE *COLUMBIA.* McFall, Imlay, and Chrisinger opened a boatyard in California in 1851. It was purchased by Coursin, Latta, and Company and then by George Eberman and Company. Fifty men worked at the yard. Over 131 boats were built there, and the boatyard's reputation reached as far as Brazil.

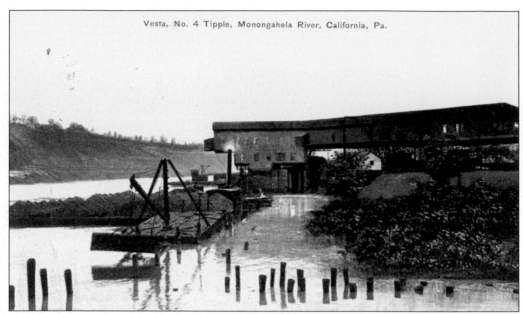

VESTA NO. 4. Seven mines were owned by the Vesta Coal Company, which became a subsidiary of the Jones and Laughlin Steel Company. Vesta No. 4 was between California and Richeyville and was one of the largest and most productive mines in the world. Vesta opened this tipple in 1903. (Courtesy of CAHS.)

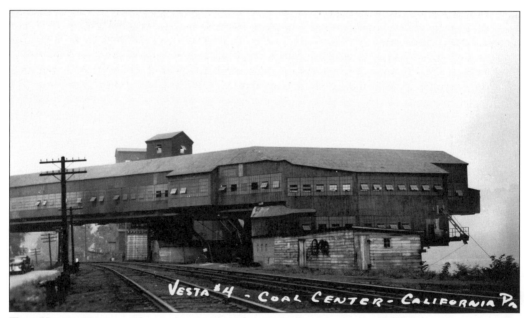

THE VESTA TIPPLE. The coal arrived at the tipple from both the California and Richeyville portals (entrances) and was dumped into awaiting railroad cars. By 1905, the mine employed 1,000 men and called itself the largest bituminous coal mine in the world. (Courtesy of CAHS.)

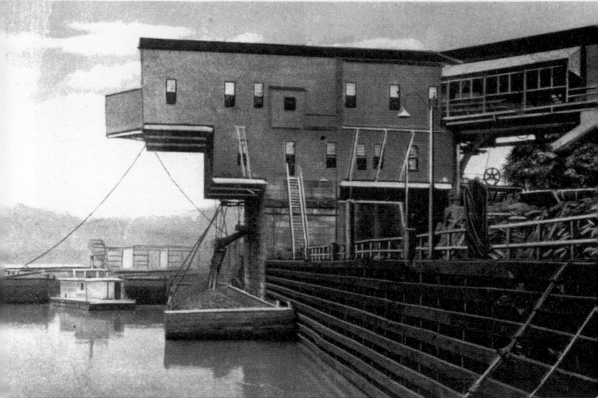

THE VESTA TIPPLE FROM THE RIVER. Dumping the coal into barges to be carried by river to awaiting industry was an alternative to railroad transportation. The tipple closed in 1957 but reopened for a short time and closed for good in 1978. The region lost 790 jobs. Additional mines in California were the Crescent, between California and West Brownsville, and the Lilley. Most of these mines were purchased by the Monongahela River Coal and Coke Company, which was founded in 1889 and called the Consolidated. (Courtesy of CAHS.)

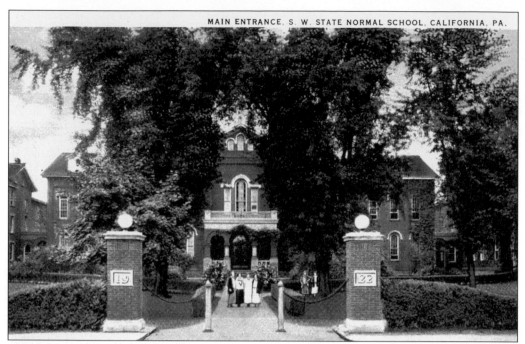

OLD MAIN. The other major industry in California was education. The California Academy was established in 1852. When it became the South Western State Normal School in 1868, the cornerstone for this building was laid. The towers and bells were added in 1869. The building was the first erected at the school.

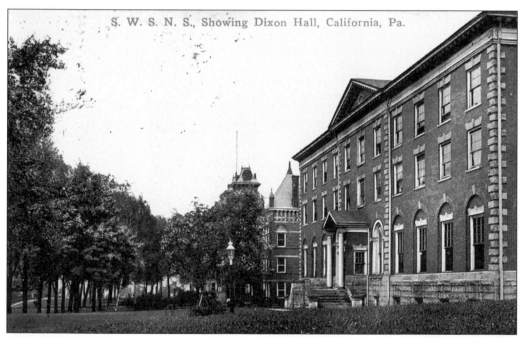

S. W. S. N. S., Showing Dixon Hall, California, Pa.

DIXON HALL, 1916. Once students began attending school from a distance, Dixon Hall, which had dormitories and a dining room, was added to the campus. It was completed in 1907 and named for John Dixon, the president of the board of trustees.

28

NORTH DORMITORY. The normal school became the California State Teachers College in 1928, the California State College in 1960, and the California University of Pennsylvania in 1982. (Published by California Pharmacy.)

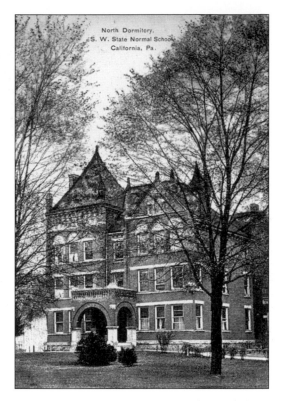

THE CHAPEL AND THEATER IN OLD MAIN. Fees at the academy were $1.50 a month, and room and board were an additional $2 a week. One of the classes offered was Chinese Water Color. Students also enjoyed theatrical presentations that were performed in this facility, which was also used as a chapel.

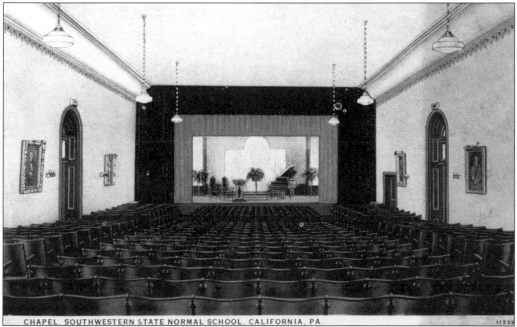

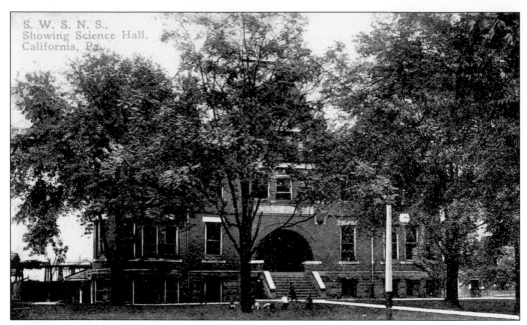

SCIENCE HALL. Science Hall was constructed in 1892. As the campus expanded, so did the attendance. Day students from around the valley arrived by train.

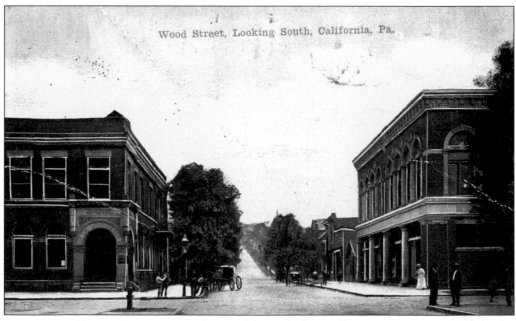

THIRD AND WOOD STREETS, C. 1911. California had a small commercial center with banks, clothing stores, and specialty shops. In 1859, there were only six stores. There were at least three hotels in the community. (Published by California Tea Company.)

THE CITY HALL AND FIREHOUSE. The municipal building, erected early in the town's history, became too small for the expanding community. It was torn down in 1996, and a new municipal building was erected. (Courtesy of CAHS.)

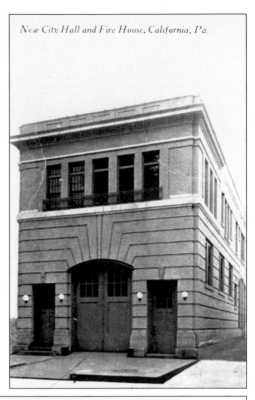

New City Hall and Fire House, California, Pa.

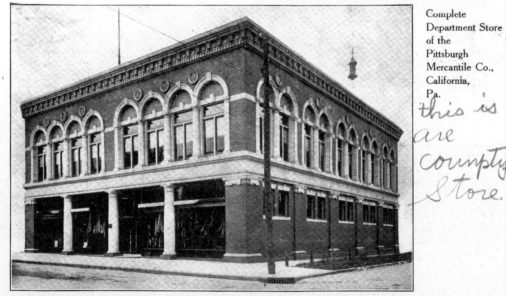

Complete Department Store of the Pittsburgh Mercantile Co., California, Pa.

this is are coumpty Store.

THE MERCANTILE BUILDING. Every coal patch had a company store where miners were required to buy their goods. A patch was several rows of company houses owned by the mine and rented to the workers. They were issued company script for their paychecks that could only be redeemed at the company store. By law, a miner had to receive at least $1 in U.S. currency. Few company stores were as large as this one; despite the coal mines, California was not a coal patch. (Courtesy of CAHS.)

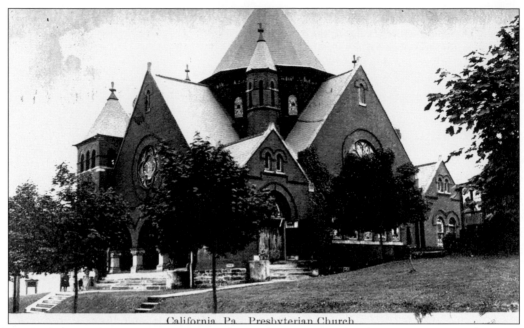

THE PRESBYTERIAN CHURCH, 1910. The Presbyterian church is located at 303 Fourth Street. A smaller community by valley standards, California has fewer churches than other communities in the valley. This church was erected in 1900.

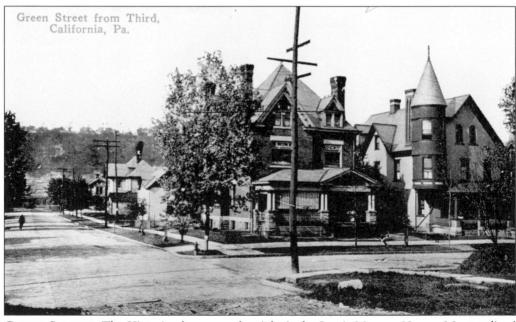

GREEN STREET. The Victorian home on the right is the Lewis Morgan House. Morgan lived here with his wife and eight children. For years the house on the left was Timko's Funeral Home. It then became the Tau Kappa Epsilon fraternity house.

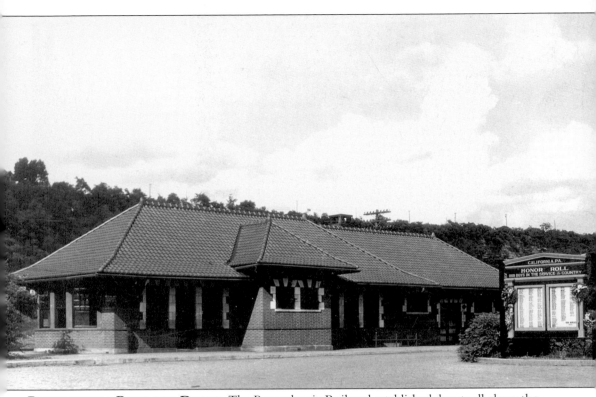

PENNSYLVANIA RAILROAD DEPOT. The Pennsylvania Railroad established depots all along the west bank of the river, beginning in 1851. This one was constructed in 1910. In 1958, it became the home of the California Public Library. (Courtesy of CAHS.)

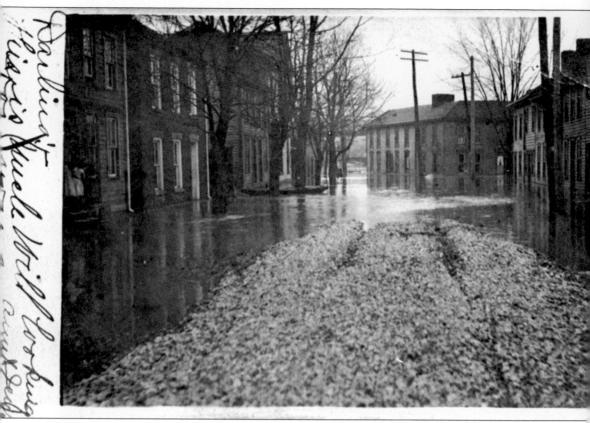

THE MAIN STREET FLOOD. Laid out by Robert Jackman in 1814, Coal Center was called Greenfield as late as 1834. Coal Center is located between a creek and the river, so every time there is high water, the streets and buildings flood.

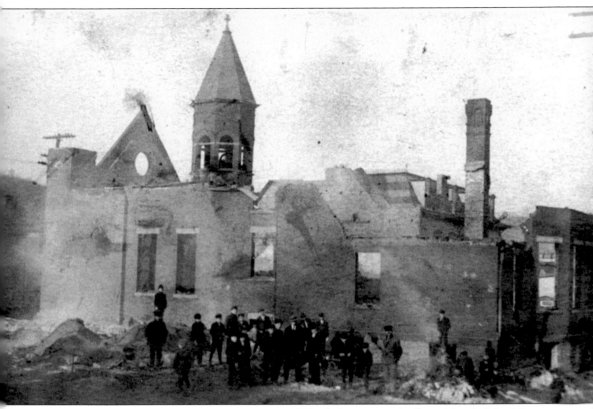

CHURCH AND PEOPLE IN COAL CENTER. By 1859, flatboats were built and loaded for New Orleans. The community became part of the Vesta Coal Company and operated Vesta No. 3 in 1892. For a small hamlet, Coal Center was a busy place with a number of churches. The mine was exhausted by 1918.

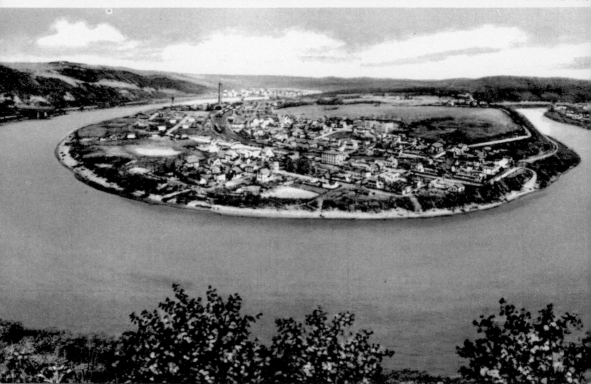

THE GREAT HORSESHOE BEND OF THE MON. The small community of Newell, originally called Marchand (founded in 1873), sits in one of the grandest horseshoes of the Mon, or any other river. The name Marchand came from a doctor who sold mad dog pills, which he maintained neutralized bites from dogs who suffered from hydrophobia. The bend has another name, the Greenfield Bend, which refers to the former name of Coal Center. The name of the town was changed when the Pennsylvania & Lake Erie Railroad, under the direction of John Newell, ran its track through town in 1910 and erected repair shops and a roundhouse. A ferry ran from Coal Center to Newell from 1879 to 1967. (Published by Minsky Brothers and Company, Pittsburgh.)

Three
FAYETTE CITY, BELLE VERNON, AND NORTH BELLE VERNON

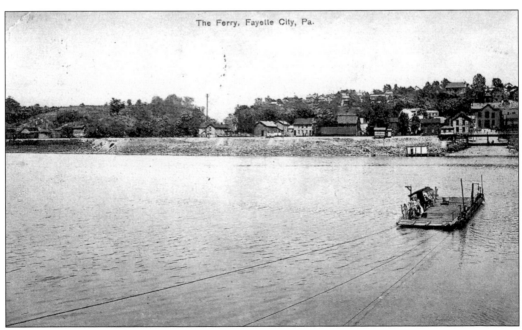

The Ferry, Fayette City, Pa.

THE FAYETTE CITY FERRY, 1912. Before bridges were built, ferries were used, and almost every town had at least one. This one was started by Francis McKee. It was later run by T. S. Chalfant and then by Joseph Krepps. It ran until 1962, when it was damaged by river ice. (Published by Lytles Pharmacy, Fayette City; courtesy of Bill Maurer.)

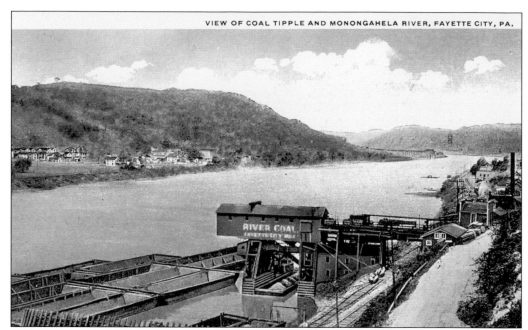

THE RIVER COAL TIPPLE, 1919. This tipple belonged to the Consolidated too. It was located along the river road (Route 906) between Fayette City and Belle Vernon. In 1903, the Consolidated merged with Pittsburgh Coal Company and became known as the Combine. (Published by I. Robbins and Son, Pittsburgh.)

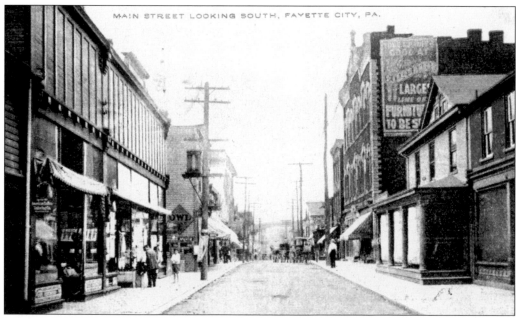

MAIN STREET LOOKING SOUTH, FAYETTE CITY, PA.

MARKET STREET IN FAYETTE CITY, 1912. Fayette City erected the first glass factory in the valley in 1833. In 1859, the community had 12 stores, 4 gristmills, 7 sawmills, 3 glassworks, and a marble works. (Published by Lytles Pharmacy, Fayette City; courtesy of Bill Maurer.)

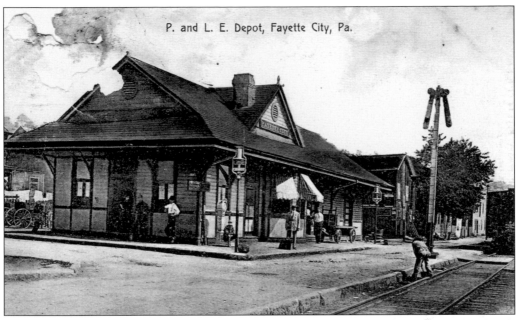

P. and L. E. Depot, Fayette City, Pa.

THE PENNSYLVANIA & LAKE ERIE DEPOT, 1910. The Pennsylvania & Lake Erie Railroad, known as the Little Giant, dominated the tracks on the east side of the river where this wooden station existed, while the Pennsylvania line owned the tracks on the west. There were other lines, but these were the dominant ones. (Published by Lytles Pharmacy, Fayette City; courtesy of Bill Maurer.)

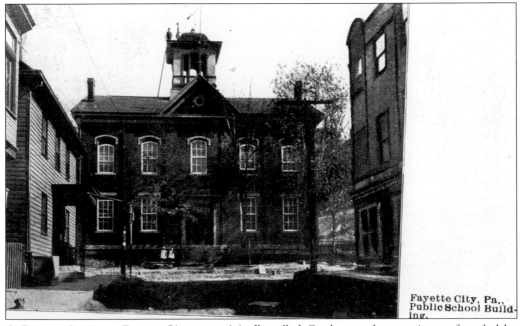

Fayette City, Pa., Public School Building.

A PUBLIC SCHOOL. Fayette City was originally called Cookstown because it was founded by Col. Edward Cook in 1800. The name was changed to Fayette City in 1854. It was never a large community and therefore had a small school district.

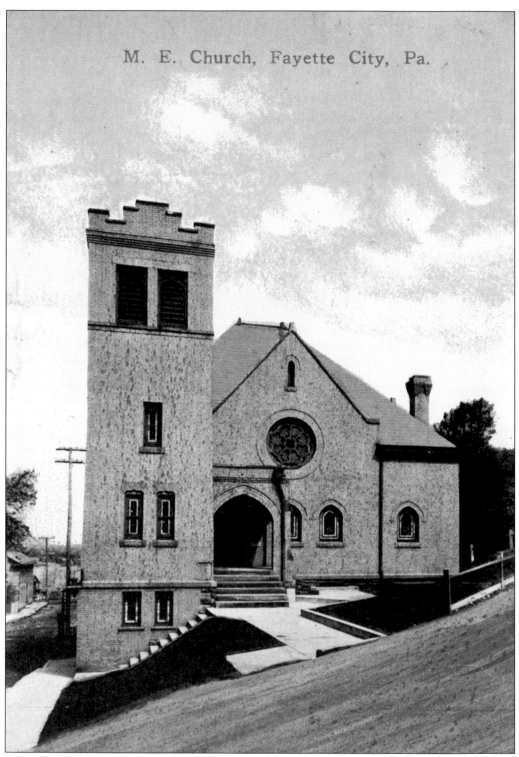

M. E. Church, Fayette City, Pa.

THE METHODIST EPISCOPAL CHURCH, FAYETTE CITY, 1916. The first church in Fayette City was erected in 1820. By 1859, there were two churches and two hotels.

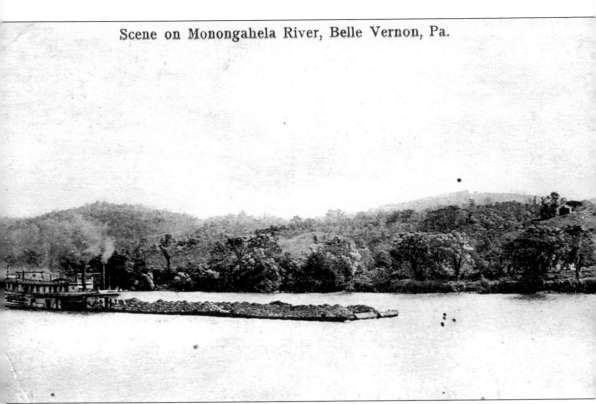

Scene on Monongahela River, Belle Vernon, Pa.

A BOAT ON THE RIVER, 1912. Solomon Speers and Morgan Gaskill ran a boatyard in Belle Vernon in the 1830s. The yard was located at Water Street and originally made keelboats. The first steamboat was the hull of the *Lancaster*, and the last was the *Katie Stockdale*. The boatyard burned in 1880. (Published by Lange's Pharmacy, Belle Vernon; courtesy of Bill Maurer.)

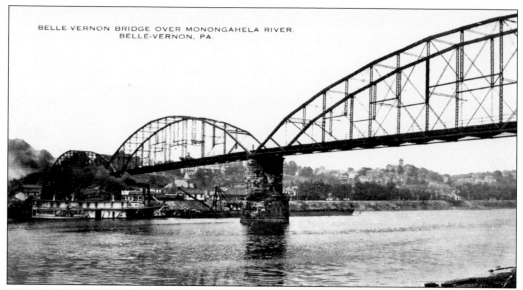

A Bridge, 1916. The Belle Vernon Bridge Company constructed the first bridge here *c.* 1890. Local stone was floated to the area on rafts and dropped into the river to build the piers. The toll bridge (with few repairs) lasted until 1940, when it was rebuilt. In turn, that bridge was torn down in 1952. (Courtesy of Bill Maurer.)

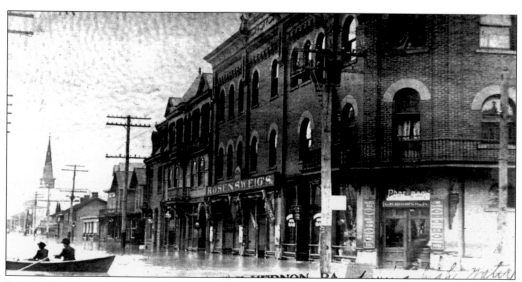

Forty-Foot Water. Melting snow and heavy rains could bring spring flooding along the Mon. The flood height for the river is around 25 feet, and most of the towns have had their streets full of water in spring. Here is a flood in front of the Birmingham Hotel. (Courtesy of Bill Maurer.)

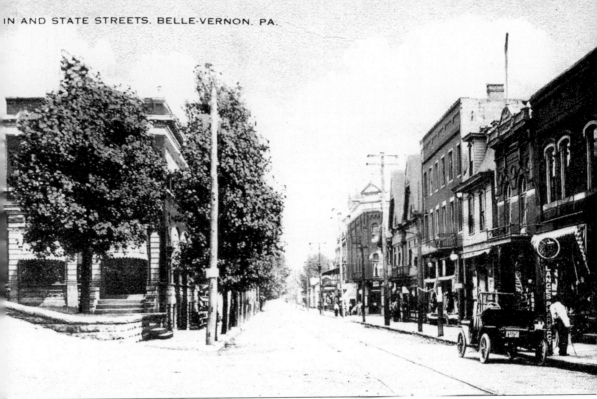

THE FORKS, 1917. Although Belle Vernon was laid out by Noah Speer in 1812, no lots were sold until 1814. Belle Vernon ran along the river in Fayette County. The road to the left in this postcard leads to North Belle Vernon, laid out in 1872 in Westmoreland County. (Courtesy of Bill Maurer.)

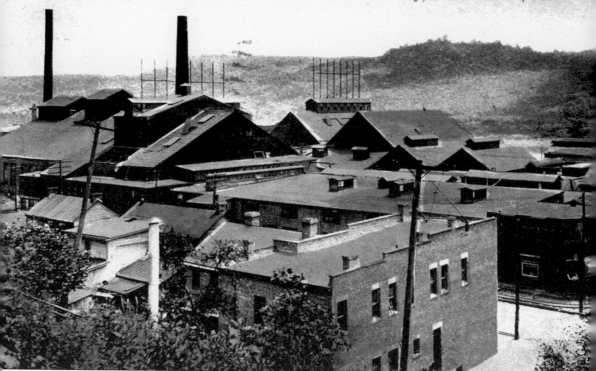

Birds:ye View, American Window Glass Factory, Belle-Vernon, Pa.

THE BELLE VERNON GLASS FACTORY. The second glass factory in the valley opened here in 1834 and soon had 10 four-pot furnaces and five flattening ovens. The factory produced 4,000 boxes of flat glass a week. It became the largest hand-blown windowpane glass factory in the nation. In 1865, it was bought by the American Window Glass Factory. By 1899, the glass factory employed 28 people. It became the first in the nation to specialize in frosted and ground glass. It had a fire on July 23, 1907, but remained in business. By 1922, 155 workers were making glass at Main and Fourth Streets. It closed in 1949.

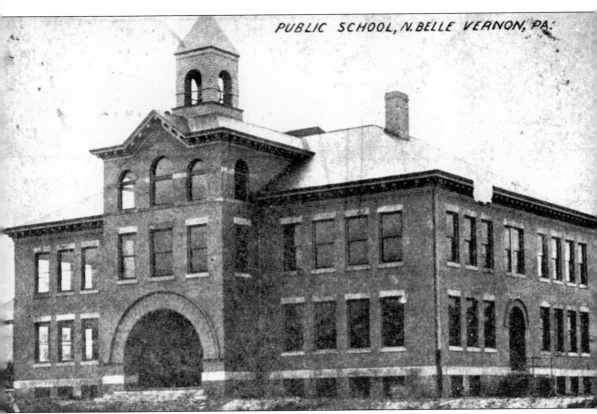

THE BELLE VERNON PUBLIC SCHOOL, 1912. The first school in Belle Vernon was erected in 1803. In 1842, Belle Vernon Academy was established by Noah Speer.

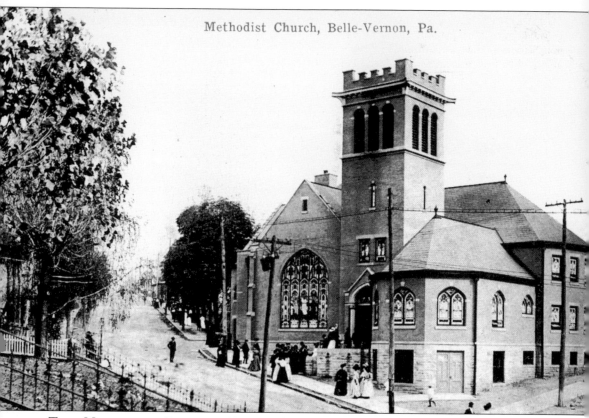

THE METHODIST CHURCH, 1911. Belle Vernon's Methodist church is still an active congregation. The building and its magnificent stained-glass window were nearly destroyed by fire a few years ago, but they were restored.

THE PRESBYTERIAN CHURCH, 1908.
Belle Vernon's Presbyterian church has a
longstanding religious community, and
many of the town leaders worshiped here.

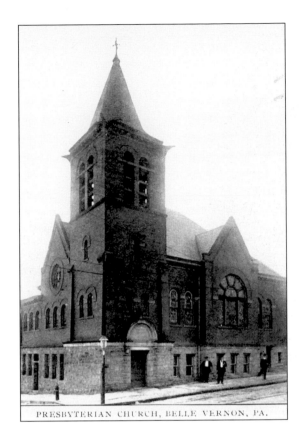

PRESBYTERIAN CHURCH, BELLE VERNON, PA.

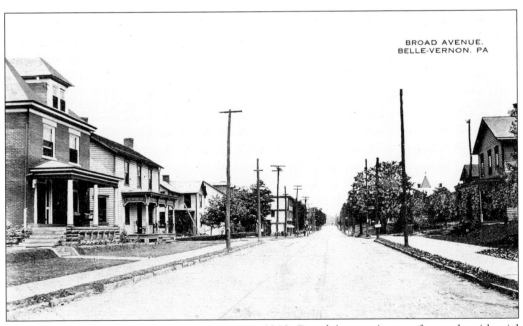

BROAD AVENUE.
BELLE-VERNON. PA

BROAD AVENUE IN NORTH BELLE VERNON, 1918. Broad Avenue is one of several residential
streets that run parallel to each other along the crest of the hill.

47

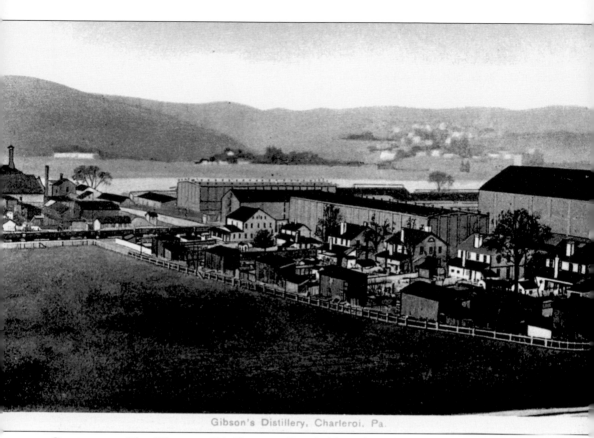

Gibson's Distillery, Charleroi, Pa.

GIBSONTON. The Gibsonton Distillery was founded by John Gibson of Philadelphia in 1854. It flourished to become the leading distillery of rye whiskey in the United States. The site grew until it contained eight bonded warehouses, a four-story malt house, a distillery, a millhouse, a drying kiln, a sawmill, a boiler, two carpenter shops, a cooper shop, a blacksmith shop, and an icehouse. It had its own dock along the river to ship the famous Monongahela rye all around the world. The community maintained a post office until 1919, the year Prohibition began. With Prohibition, the distillery was decimated and forced into bankruptcy. Nothing remains. The postcard is wrong in stating that the distillery was in Charleroi. It was in Gibsonton across the river from Charleroi between Belle Vernon and Monessen. In 1893, a ferry operated by John Irons ran from Charleroi to Gibsonton. (Published by the American News Company, New York, New York.)

Four

CHARLEROI AND LOCK NO. 4

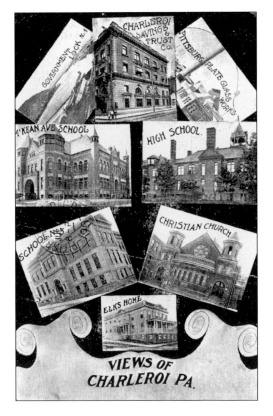

VIEWS OF CHARLEROI, 1907. The Charleroi Land Company founded a community in 1890 with intentions of making glass, so the community was named Charleroi after the famous glass city in Belgium. Experts from Belgium came to work at the first glass facility. (Published by Anglo-American Post Card Company, New York, New York; courtesy of Charlene Lario.)

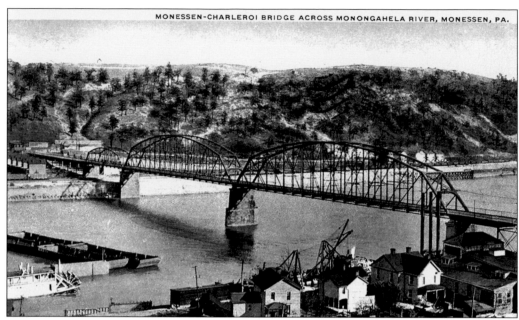

THE CHARLEROI-MONESSEN BRIDGE, 1921. One has choices of how to cross the river to Charleroi. The Belle Vernon bridge and Interstate 70 lie to the south, and the Charleroi-Monessen Bridge, seen here, crosses the Mon to the north. (Published by I. Robbins and Son, Pittsburgh.)

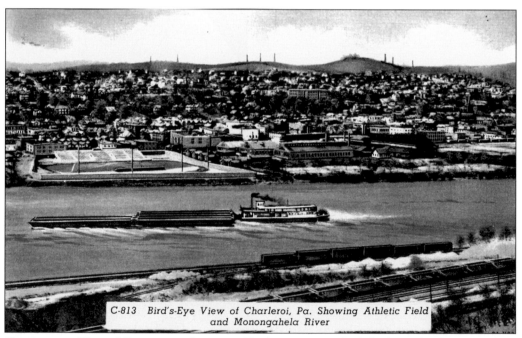

C-813 Bird's-Eye View of Charleroi, Pa. Showing Athletic Field and Monongahela River

CHARLEROI. Viewed from across the Mon, Charleroi rises up the hillside. In the foreground are the municipal stadium and the glass factories upon which the economy was based. (Published by Minsky Brothers and Company, Pittsburgh.)

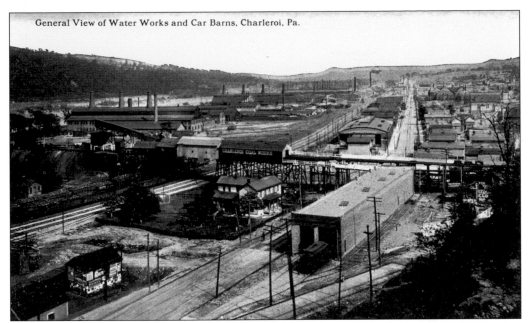

General View of Water Works and Car Barns, Charleroi, Pa.

A BIRD'S-EYE VIEW. At the northern entrance to the community stood a number of businesses. The carbarn for the trolley, the Charleroi coal tipple, and the glass factories are visible here. (Published by I. Robbins and Son, Pittsburgh; courtesy of Al Protin.)

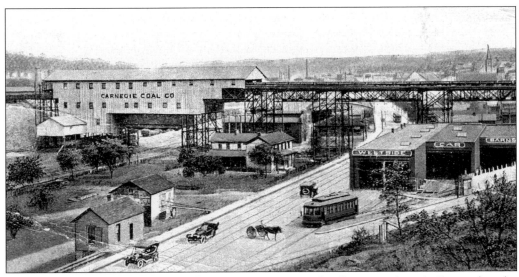

A SECOND BIRD'S-EYE VIEW. The same scene repeated a few years later indicates that the Charleroi Coal Company, owned by Pittsburgh Plate Glass, was sold to the Carnegie Coal Company. (Courtesy of Al Protin.)

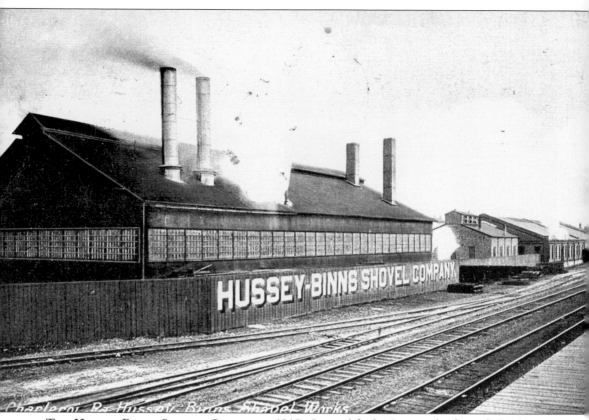

Charleroi Pa Hussey Binns Shovel Works

THE HUSSEY BINNS SHOVEL COMPANY, 1915. Opened for business at the foot of Third Street in 1874, the Hussy Binns Shovel Company began making shovels for the coal industry in 1891. Although there was a devastating fire in 1902, Hussey remained open for 50 years. The business was sold to the Universal Rolling Mill Company. Another mining company was the Charleroi Iron Works, which made mine shuttle cars and developed the first loading machines for mines in 1921. Charleroi Iron Works became known as Lee Norse in 1940. Norse became the largest manufacturers of continuous and long-wall machines for coal mines in the world. Norse was purchased and closed by Ingersoll Rand in 1988. (Published by Hugh C. Leighton Company, Portland, Maine; courtesy of Charlene Lario.)

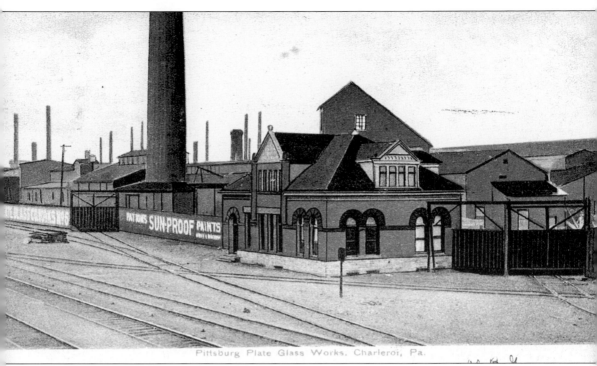

Pittsburg Plate Glass Works, Charleroi, Pa.

GLASS, 1908. The Charleroi Plate Glass Company, the first industry in Charleroi, was founded in 1890 and collapsed in the panic of 1893. It was purchased by the Pittsburgh Plate Glass Company and called Works No. 6. It closed in the 1930s. The MacBeth Glass Company began in 1893 and merged with Evans Glass a short time later. It was the largest producer of glass chimneys and depression glass, but by 1912 it began to produce high-quality optical glass, including lighthouse lenses. It was bought by the Corning Glass Works of New York in 1937. Corning was established in 1893. At its peak, Corning Glass in Charleroi employed 1,444 men and 739 women. They made a number of products, including Pyrex, steuben, and bakeware. Corning's business declined in the 1970s but revived in the 1980s. (Published by the American News Company, New York, New York; courtesy of Charlene Lario.)

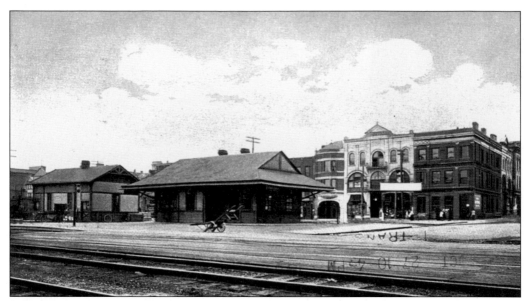

THE PENNSYLVANIA (PENNSY) STATION, 1908. These wooden stations were built by the Monongahela Valley Railroad Company, organized in April 1867. In February 1870, the Monongahela Valley Railroad Company became the Pittsburgh, Virginia, and Charleston Railway Company (PVC). The Pennsy bought the PVC in 1879, and it became their Monongahela Division. Eventually, three lines ran the rails using six trains a day that traveled both north and south. (Published by Hugh C. Leighton Company Manufacturers, Portland, Maine.)

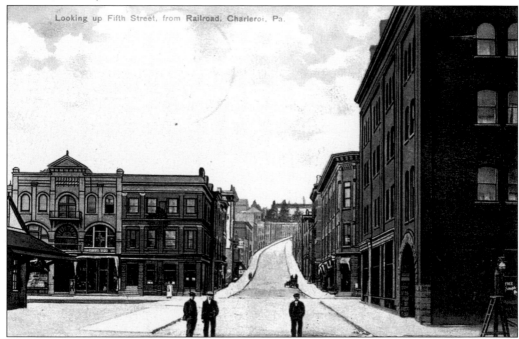

FIFTH STREET, LOOKING WEST, 1906. There was a square around the train station. The west side is shown in this view looking up Fifth Street. The Charleroi Hotel is on the right. (Published by the American News Company.)

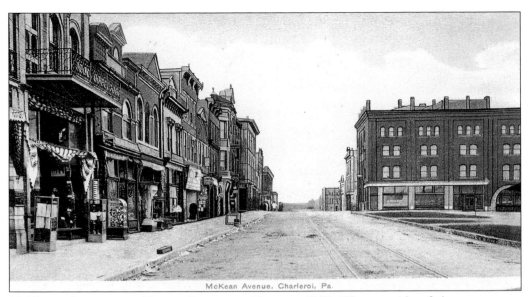

MCKEAN AVENUE AT FIFTH, LOOKING NORTH, 1912. The top side of the square was McKean Avenue. The Charleroi Hotel is on the right in this image. (Published by I. Robbins and Son, Pittsburgh; courtesy of Charlene Lario.)

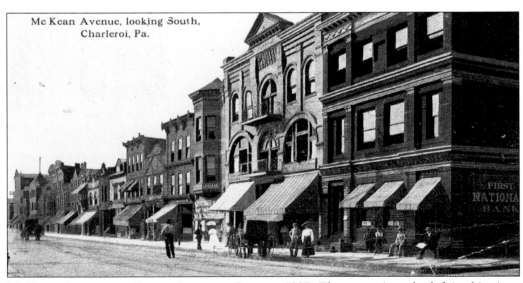

MCKEAN AVENUE AT FIFTH, LOOKING SOUTH, 1907. The square is to the left in this view. Shown are the businesses on McKean, one of the busiest shopping streets in the valley. (Published by the American News Company, New York, New York; courtesy of Charlene Lario.)

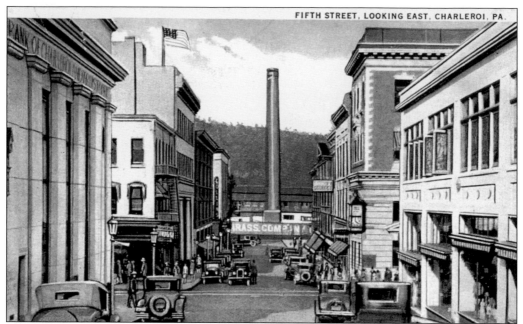

FIFTH STREET, LOOKING EAST, 1917. Completing the tour around the square, this is Fifth Street as it approaches the square. Note that the Pittsburgh Plate Glass factory is directly across the tracks. (Published by I. Robbins and Son, Pittsburgh; courtesy of Charlene Lario.)

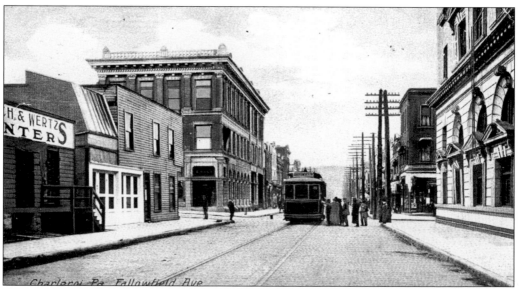

FALLOWFIELD AVENUE. Fallowfield is the second avenue in Charleroi's business district. Streetcars, seen here, were yet another way of getting around the valley. Several lines existed to link the various communities. (Courtesy of Bill Maurer.)

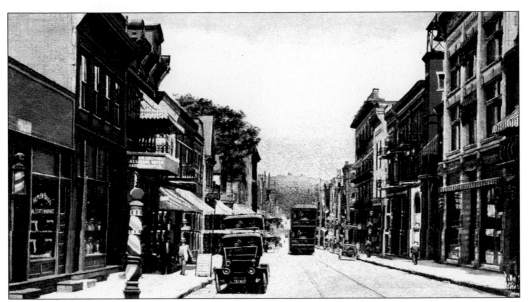

FALLOWFIELD AVENUE, 1917. It is alleged that the first lot purchased in Charleroi was on Fallowfield. It became the home of Bowers Hardware. Note the barbershop pole in this postcard. (Courtesy of Charlene Lario.)

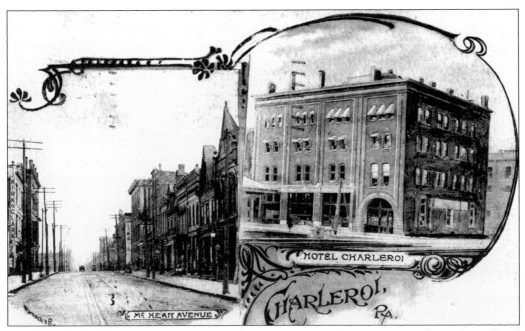

THE CHARLEROI HOTEL, 1906. Located at 500 McKean Avenue across from the railroad station, the Charleroi Hotel became the largest of the 10 hotels in town. It was torn down and replaced by a square in 1980.

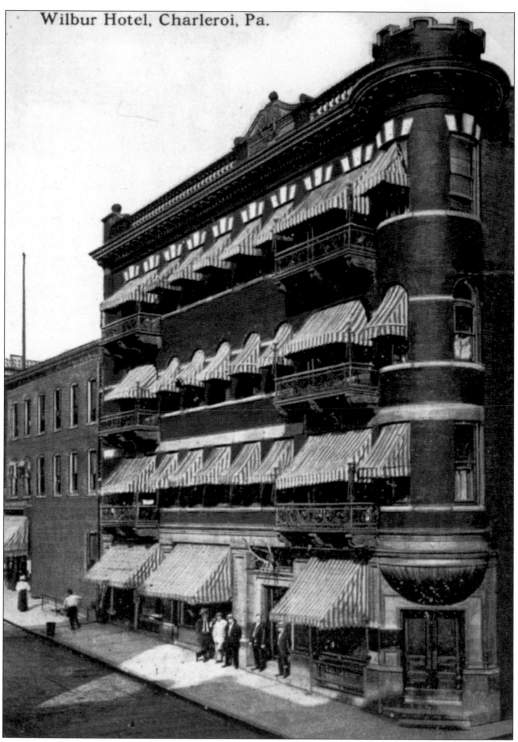

Wilbur Hotel, Charleroi, Pa.

THE WILBUR HOTEL, 1914. The Wilbur no longer stands, but in its heyday its distinct architecture helped make it one of the most important hotels in Charleroi. (Published by I. Robbins and Son, Pittsburgh; courtesy of Charlene Lario.)

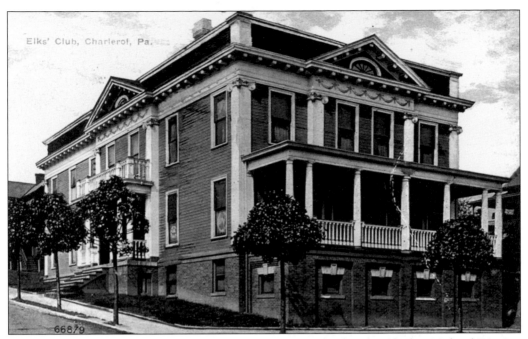

THE ELKS CLUB AND FORMER SCHOOL, 1911. Once a school in the Charleroi School District, this large building on Fallowfield Avenue has been owned by the Elks for some time.

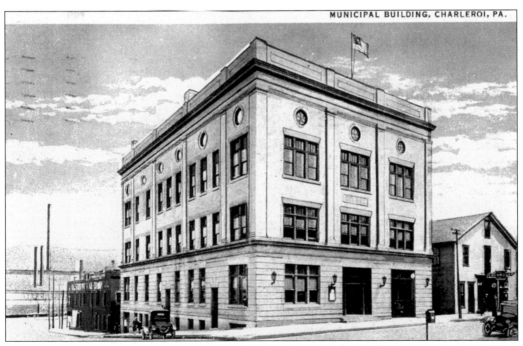

THE MUNICIPAL BUILDING, 1935. Located at Fourth and Fallowfield, the municipal building was opened in 1917. It contains the city offices, the jail, and the fire department. An auditorium was on the top floor. (Published by Curt Teich and Company, Chicago, Illinois.)

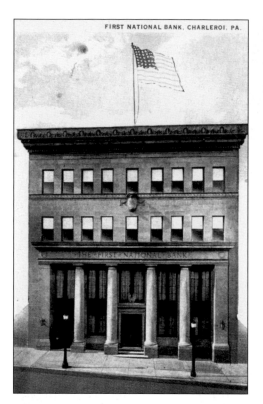

THE FIRST NATIONAL BANK. The first bank in Charleroi opened in 1891 at Fifth and McKean. It was designed by William Lee Stoddard. It was replaced by a brick building in 1927. (Published by I. Robbins and Son, Pittsburgh.)

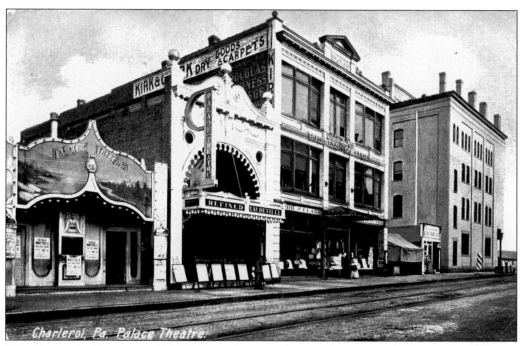

THE ELECTRIC THEATER, 1908. The single-story Electric Theater was the fourth movie theater in the United States. It was built in 1905. (Published by Hugh C. Leighton Company, Portland, Maine.)

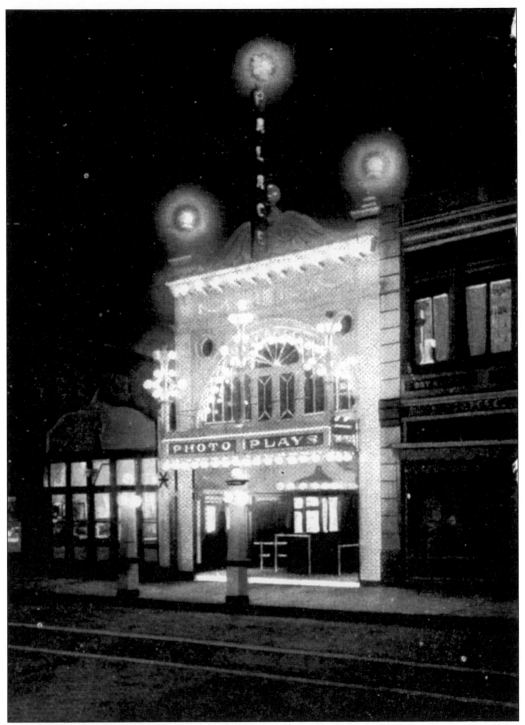

THE PALACE THEATER AT NIGHT, 1924. Next to the Electric was the Palace, begun by R. L. Barnhardt in 1904. The two were combined in 1907 and held 650 seats. Eventually, Charleroi had eight theaters, including the Coyle, which is still standing. (Published by I. Robbins and Son; courtesy of Bill Maurer.)

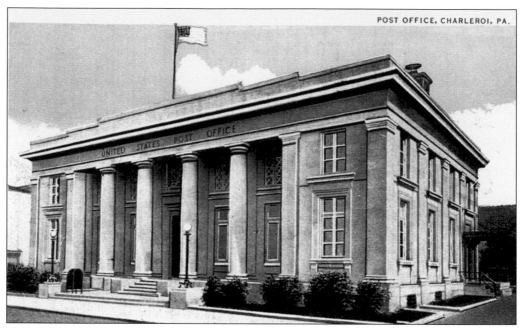

THE CHARLEROI POST OFFICE. This classic structure opened in 1913 at 11th and Fallowfield to replace a previous post office. In 1980, it was converted to the community library and named after John K. Tener, a Charleroi citizen who was the governor of Pennsylvania from 1911 to 1915.

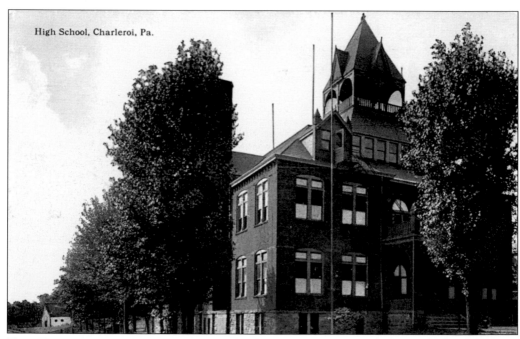

High School, Charleroi, Pa.

THE FIFTH STREET SCHOOL, 1913. The first high school was built in 1892 at Fifth and Meadow. It had eight rooms and graduated its first class in 1894. (Published by I. Robbins and Son, Pittsburgh.)

62

THE NINTH STREET SCHOOL. All of Charleroi's schools were noted for their distinct architectural styles. This one is particularly stunning. Sadly, most no longer grace the community. (Published by Hugh C. Leighton Company, Portland, Maine; courtesy of Charlene Lario.)

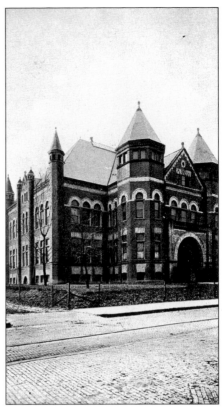

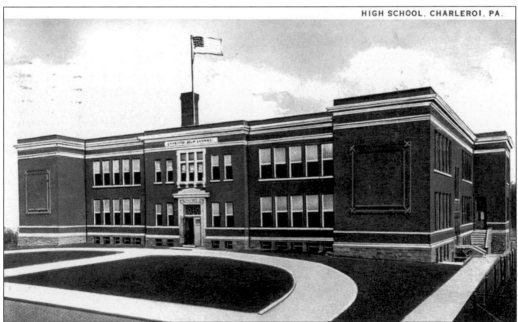

HIGH SCHOOL, CHARLEROI, PA.

THE HIGH SCHOOL, 1930. The second high school was built at Sixth and Crest. Two wings were added in 1917. It was replaced by a new facility in 1965. (Published by I. Robbins and Son, Pittsburgh.)

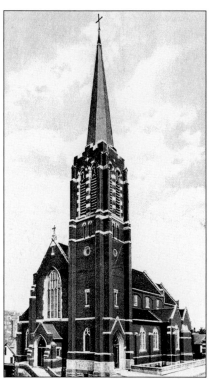

ST. JEROME'S CATHOLIC CHURCH. Every Catholic church in the valley usually served a single immigrant group. Charleroi had three Catholic churches. They merged in 1992 into the Mary Mother of the Church parish, located in this former St. Jerome's structure at 624 Washington. (Published by I. Robbins and Son, Pittsburgh; courtesy of Charlene Lario.)

THE PRESBYTERIAN AND LUTHERAN CHURCHES, 1914. The Presbyterian Church of Charleroi (left) was founded in 1891, and the building was eventually erected on Washington Avenue. It was rebuilt in the 1960s on Fifth Street. There are two Lutheran churches in Charleroi: an English and a Slovakian. (Left, published by Hugh C. Leighton Company, Portland, Maine.)

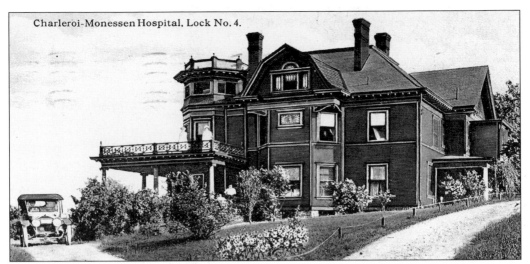

Charleroi-Monessen Hospital, Lock No. 4.

THE CHARLEROI-MONESSEN HOSPITAL, 1916. Originally opened by Dr. G. A. Dillinger on May 9, 1909, the facility eventually became Monessen General Hospital and was relocated to Lock No. 4 in 1913. (Published by I. Robbins and Son, Pittsburgh; courtesy of Charlene Lario.)

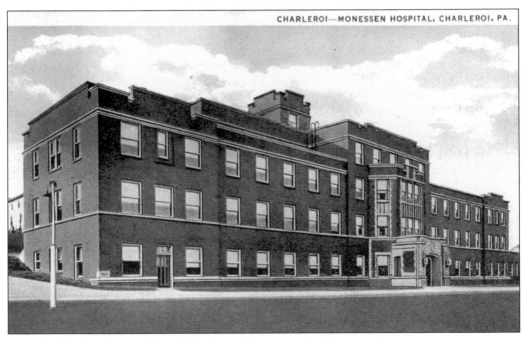

CHARLEROI—MONESSEN HOSPITAL, CHARLEROI, PA.

THE CHARLEROI-MONESSEN HOSPITAL, 1935. This building was built in 1930. It operated using 84 beds. In 1972, the Charleroi-Monessen Hospital merged with the Memorial Hospital of Monongahela and became the Monongahela Valley Hospital. (Published by Curt Teich and Company, Chicago, Illinois.)

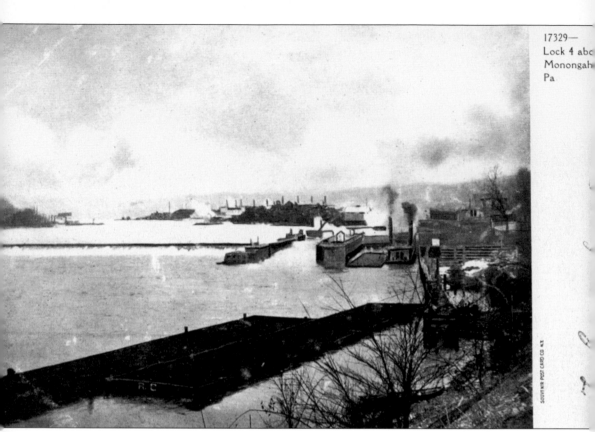

LOCK NO. 4 BEFORE THE BRIDGE. Lock No. 4 is one of seven locks originally built by the Monongahela Navigation Company south of Pittsburgh. Once four of those locks were in place, industry flourished as the river became viable in both winter and summer from Pittsburgh to Brownsville. The first lock at No. 4 was built of cut stone and erected in 1844. It had hand-operated wooden gates and was located on the west side of the river. The dam spanning the river was built of timber and stone. This view of the lock shows Charleroi in the background and was taken prior to the erection of the Charleroi-Monessen Bridge.

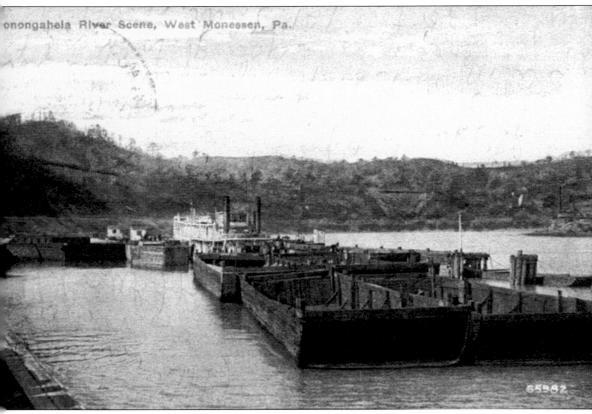

onongahela River Scene, West Monessen, Pa.

65982

LOCK NO. 4. Looking north from the lock, this image offers a fine view of wooden barges. In the previous image they were loaded, thus low in the water. Here, they are empty, providing a better view. Barges grew out of the flatboats, which were originally used to carry coal.

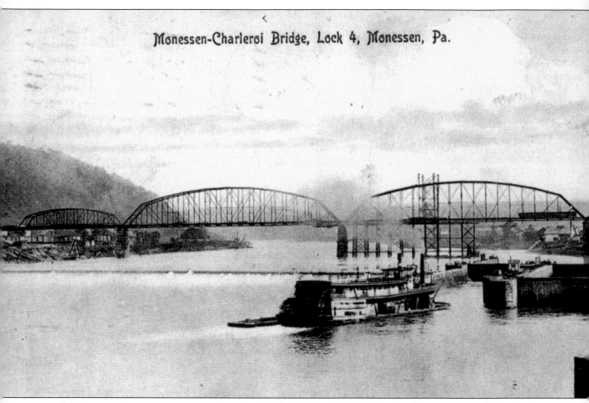

Monessen-Charleroi Bridge, Lock 4, Monessen, Pa.

A PADDLEWHEELER AT THE LOCK, 1909. By the 1880s, the government owned the locks, and the U.S. Army Corps of Engineers built two more on the Mon, extending industry even farther south. Here is a paddlewheeler entering the lock with a barge of coal lashed to its side.

The lock was enlarged and moved to the opposite side of the river, 41.5 river miles from Pittsburgh in the 1880s. When that was accomplished, the water depth in the pool was approximately six feet. Even heavier boats could now navigate the waterway. However, the size of the lock eventually limited the size of the boat, and eventually that led to enlargement once again. Over 70 million tons of coal passed through this lock in 1970. Coal is still the major product passing through Lock No. 4. (Published by J. B. White, Monessen.)

Five

MONESSEN

Greetings from MONESSEN, PA.

P. & L. E. DEPOT

GREETINGS FROM MONESSEN. Monessen was founded as a speculative industrial town in 1898 when the East Side Land Company bought the land, laid out the town, and contracted for the construction of a tin and a steel mill. (Published by F&H Levy Manufacturing Company, New York, New York.)

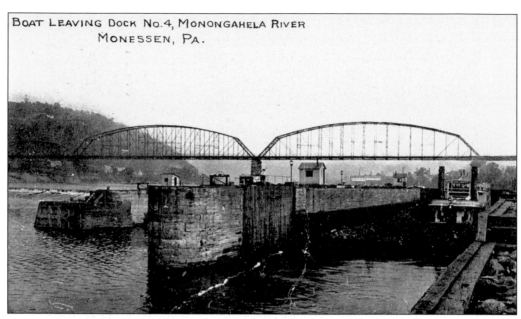

BOAT LEAVING DOCK No.4, MONONGAHELA RIVER
MONESSEN, PA.

THE BRIDGE. The Charleroi-Monessen Bridge was built by the Mercantile Bridge Company and opened for traffic in 1907. Simultaneous celebrations took place in Monessen and Charleroi. The toll was 3¢. By 1957, when it became a free bridge, the toll had climbed to 10¢. (Published by J. B. White, Monessen.)

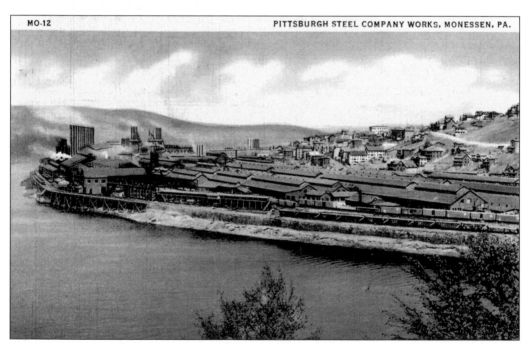

MO-12 PITTSBURGH STEEL COMPANY WORKS, MONESSEN, PA.

THE PITTSBURGH STEEL COMPANY, 1939. The full breadth of Pittsburgh Steel is visible in this image. This steel mill was the largest employer in the Mid Mon Valley, and at its peak 10,000 men, from engineers to laborers, worked in the various departments. Women worked mainly in the offices. (Published by Minsky Brothers and Company, Pittsburgh.)

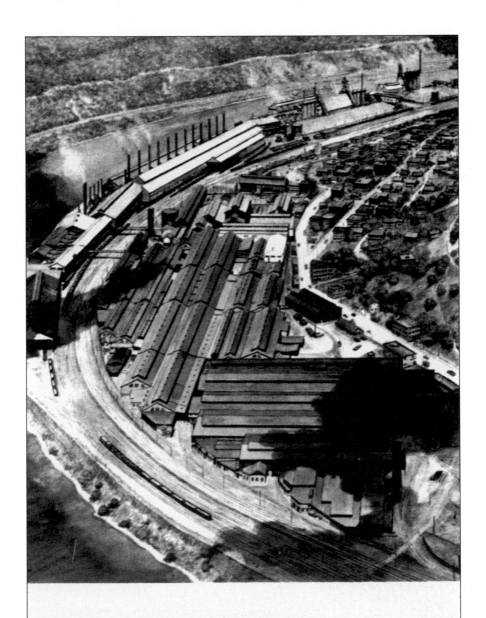

The plant of the Pittsburgh Steel Company surrounds P&LE main line through Monessen, Pa. One of a series of paintings by Howard Fogg of the Pittsburgh and Lake Erie Railroad and the industries it serves.

A HOWARD FOGG PAINTING OF PITTSBURGH STEEL. Howard Fogg, the famous industrial painter, was hired by the Pennsylvania & Lake Erie Railroad to paint images of its right-of-way in the Mon Valley. He created two images of Pittsburgh Steel. This is his aerial view of the industrial complex in Monessen. The 12 stacks ventilate the open hearth. The blooming mill is below the open hearth and blast furnaces one and two above. Jane furnace was not yet built. (Art Creation in Curteichcolor.)

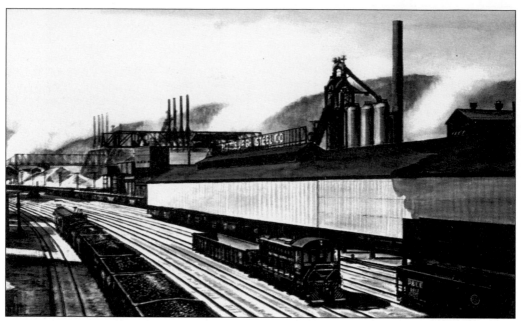

HOWARD FOGG. The second Howard Fogg view of Pittsburgh Steel features the Pennsylvania & Lake Erie tracks in front of the blast furnaces. Various raw materials were brought to the steel mill via rail and boat to feed the furnaces to make steel. (Art Creation in Curteichcolor.)

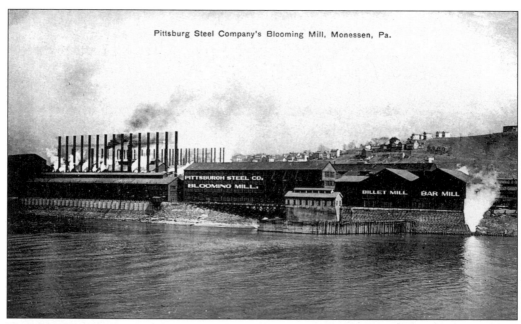

Pittsburg Steel Company's Blooming Mill, Monessen, Pa.

THE PITTSBURGH STEEL COMPANY. Shown here are Pittsburgh Steel's blooming, billet, and bar mills as they appeared *c.* 1915. Note the empty hillside behind the mill. The top of the hill is probably Highland Avenue. (Published by L. F. Harbaugh, Monessen.)

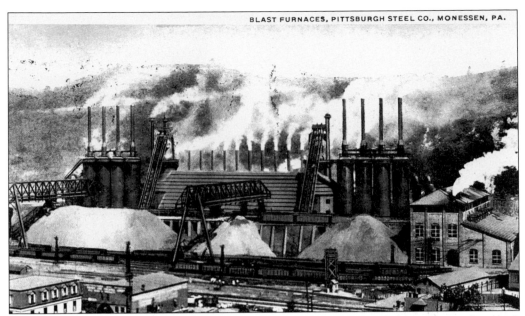

BLAST FURNACES, 1921. Construction on No. 1 (right) and No. 2 (left) blast furnaces began on March 11, 1912. They were blown in August 1913, and in 1914, No. 1 held the world record in production. In 1995, an attempt to save a blast furnace failed. In 1996, demolition began. (Published by I. Robbins and Son, Pittsburgh.)

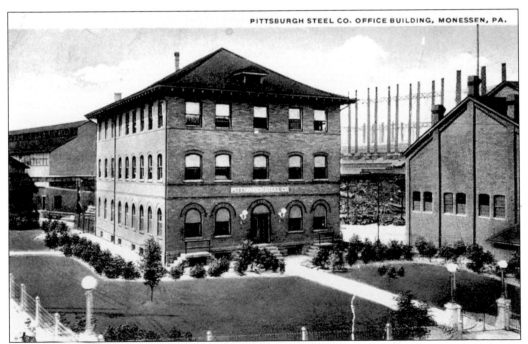

THE OFFICE. The Monessen office at 12th Street was a masterpiece of Georgian-style architecture. After 1915, a third floor was added to the office building, and a bridge linked it to the machine shop next door. Short-sighted redevelopment demolished it in the 1990s. (Published by I. Robbins and Son, Pittsburgh.)

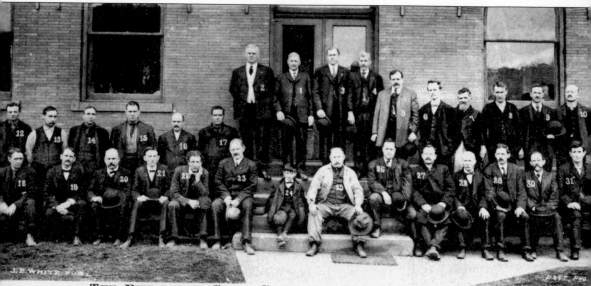

THE PITTSBURGH STEEL COMPANY'S FOREMEN—MONESSEN, PA.

GEORGE NASH, Gen'l Sup't.　2. C. J. MORGAN, Sup't Classport Mill.　3. A. ALLISON, Gen'l Foreman Seamless Tube Co.　4. JAS. NASH, SR., For
Wire Mill.　5. W. H. WAGONER, Foreman Rod Mill.　6. E. SYMONDS, Foreman Boiler House.　7. HARRY ZELL, Foreman Bricklayers.　8. SAMUEL
Asst. Master Mechanic.　9. JOHN D. MILLER, Chief Draftsman.　10. J. E. BOWLIN, Foreman Machine Shop No. 1.　11. JOSEPH CADWALL.
Foreman Carpenter Shop.　12. JAC. SMITH, Labor Boss.　13. THOS. GILCHRIST, Foreman Machine Shop No. 2.　14. E. S. METZ, Asst. Foreman
Mill.　15. F. C. MILLER, Foreman Galvanizing D-pt.　16. JAS. ADAMS, Foreman Pattern Shop.　17. AUG. JOHNSTON, Foreman B. W. & F. F. D
8. JOS. S. SMITH, Master Mechanic O. H. Dept.　19 GEO. STAHLNECKER, Foreman Blooming Mill.　20. JAS. ROBERTSON, Master Mechanic.　21. D. P.
Chief Clerk.　22. D. J. McMAHAN, Chief Shipper.　23. J. G PARKE, JR., Chief Engineer.　24. JAS. NASH, JR.　25. D. J. O'ROURKE, For
Rail Mill.　26. W. L. FORESTER, Foreman O. H. Dept　27. FRED. LINK, Foreman Bricklayers, O. H. Dept.　28. JOHN GAFFNEY, Chief Watch
9. J. H. WATT, Chief Chemist.　30. F. H WOOD, Chief Electrician.　31. JOS. WILSON, Labor Boss, O. H. Dept.

THE PITTSBURGH STEEL COMPANY. This card shows the foremen of Pittsburgh Steel.

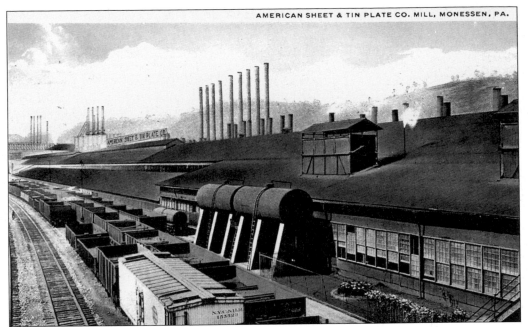

THE AMERICAN SHEET AND TIN PLATE COMPANY MILL, 1921. The Tin Mill, as it was known in the valley, dominated the Monessen landscape around Sixth Street. It was built by William H. Donner. (Published by I. Robbins and Son, Pittsburgh.)

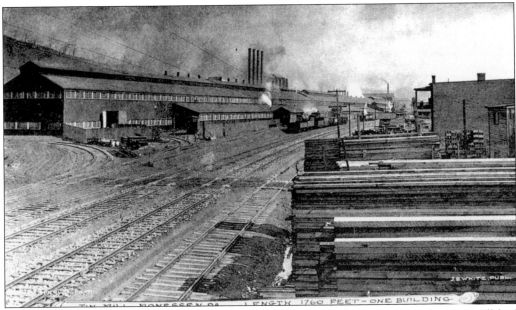

THE TIN MILL, 1908. The first plate was rolled in February 1898. By 1904, the Tin Mill had 25 separate mills and was "one of the largest and most thoroughly equipped tin plate plants in the world." It closed in 1937. (Published by J. B. White.)

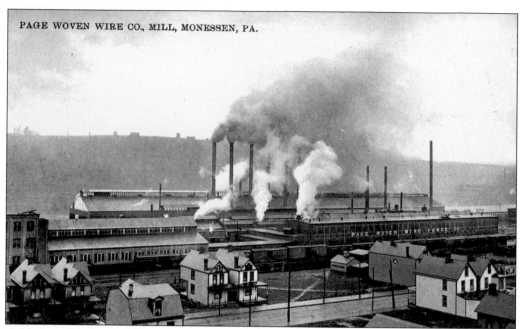

PAGE WOVEN WIRE CO., MILL, MONESSEN, PA.

THE PAGE WOVEN WIRE COMPANY. Page Woven Wire occupied 22 acres between Donner Avenue and the river at First Street. It was sold to American Chain in 1920. Wire from Page's was used in the construction of the Golden Gate Bridge. In 1972, it closed for good. (Published by Hirsch Drug Company, Monessen.)

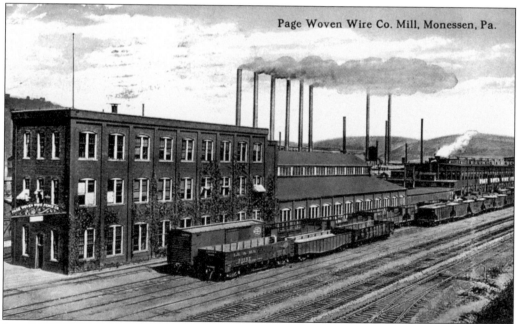

Page Woven Wire Co. Mill, Monessen, Pa.

PAGE'S AS CARNEGIE STEEL, 1914. The main office and factory of Page Woven Wire and Fence Company *c.* 1911 was just across the railroad tracks beyond Second and Donner. (Published by I. Robbins and Son, Pittsburgh.)

76

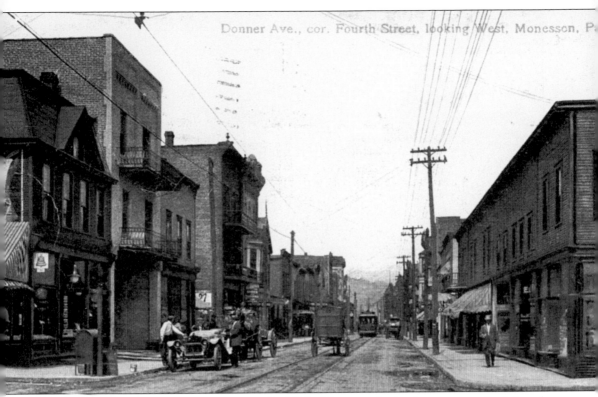

FOURTH AND DONNER, LOOKING WEST. In 1901, this corner had a drugstore on the left and the Eggers and Graham Planning Mill on the right. In 1908, the drugstore existed in a new building and a millinery shop was on the right. (Courtesy of Ken Harhai.)

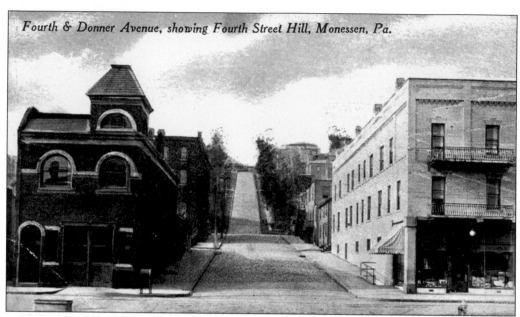

Fourth & Donner Avenue, showing Fourth Street Hill, Monessen, Pa.

FOURTH AND DONNER. The first Monessen Municipal Building stood on the corner of Fourth and Donner. It contained the fire hall and the jail. People could talk to the prisoners from the sidewalk. Kirk's Drug Store was in the white brick building (still standing) on the right. (Published by W. P. Kirk, Monessen.)

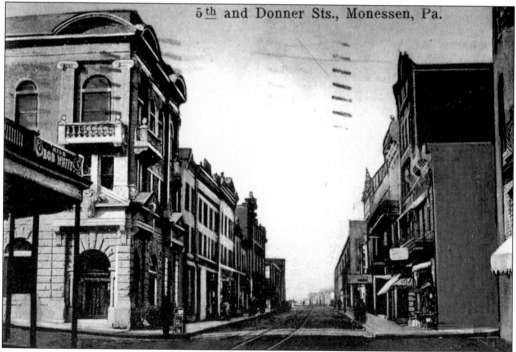

5th and Donner Sts., Monessen, Pa.

FIFTH AND DONNER, LOOKING WEST, 1908. The posts and balcony of the Monongahela House can be seen on the left. Across Donner was the Monessen Hotel. Both were still open for business in 1925 but were gone by the 1940s. (Published by J. B. White.)

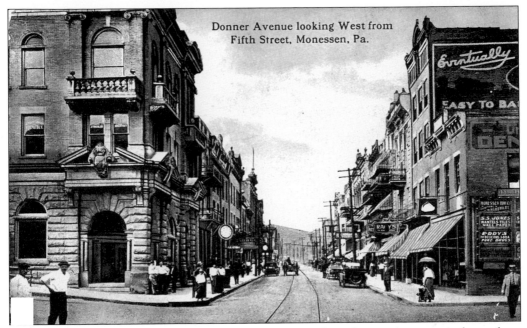

Donner Avenue looking West from
Fifth Street, Monessen, Pa.

FIFTH AND DONNER, LOOKING WEST. The same scene from the previous page is shown here a decade later with the Monessen Savings Bank in the foreground. The clock is a Brown Street clock, shipped all over the United States by the company of the same name. (Published by I. Robbins and Son, Pittsburgh.)

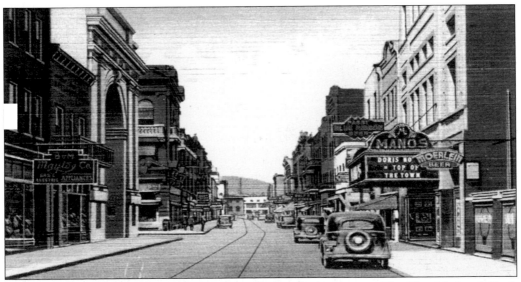

FIFTH AND DONNER, 1940. By the 1940s, the hotels were gone. The First National Bank replaced Monongahela House. The Olympic Theater was replaced by the Manos. It would become the Grand when the Manos opened a new facility in the 1950s. (Published by Minsky Brothers and Company, Pittsburgh; courtesy of Bill Maurer.)

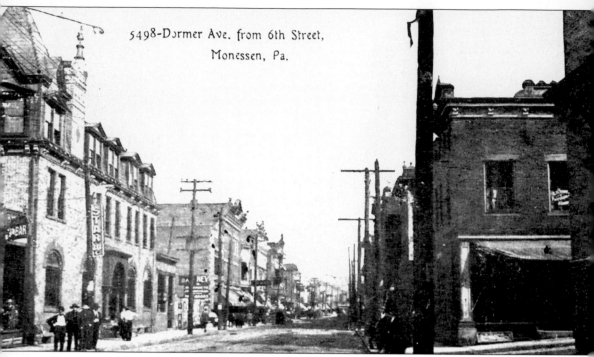

5498-Dormer Ave. from 6th Street,
Monessen, Pa.

SIXTH AND DONNER, LOOKING EAST. In 1911, the May Hotel (left), which had a wonderful Gothic tower, replaced the Alexander Hotel of 1901. (Published by N. E. Paper and Stationery Company, Ayer, Massachusetts; courtesy of Bill Maurer.)

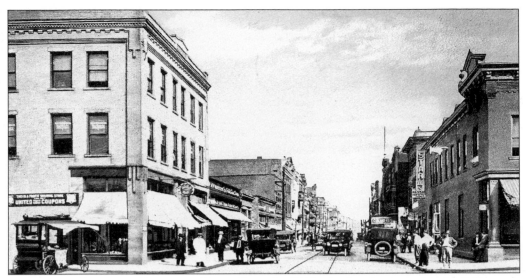

SIXTH AND DONNER, LOOKING EAST. Later in 1911, the hotel was replaced with a new building that held a grocery and furniture store. (Published by I. Robbins and Son, Pittsburgh; courtesy of Bill Maurer.)

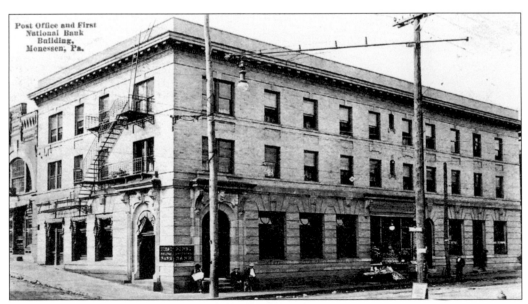

THE FIRST NATIONAL BANK BUILDING. On the west corner of Sixth and Donner stood the bank building. The post office was located in the extreme right side of the building in 1909. (Courtesy of Bill Maurer.)

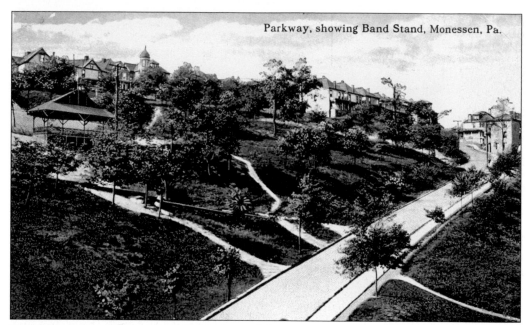

THE PARK AND BANDSTAND, 1919. Around the corner at Sixth and Schoonmaker stood one of a number of Monessen Parks: Sixth Street Park. Band concerts were held here, and the students from the schools held contests to plant the trees. (Published by I. Robbins and Son, Pittsburgh.)

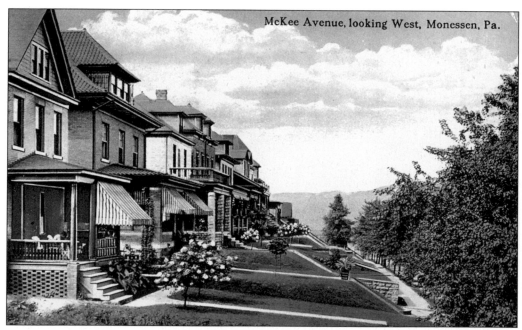

MCKEE AVENUE, LOOKING WEST, 1917. McKee runs the length of the community just above the business district. It has many fine homes. McKee is shown in a view looking west from Oneida. (Published by I. Robbins and Son, Pittsburgh.)

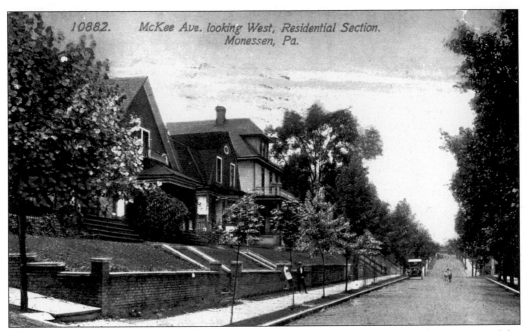

McKee Avenue, Looking West, 1914. Most of the homes on McKee were occupied by businessmen and mill superintendents. They often had third-floor accommodations for servants. (Published by the Acmegraph Company, Chicago, Illinois.)

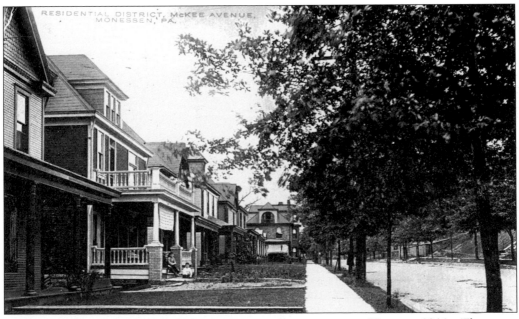

McKee Avenue, Looking East between Fourth and Ninth, 1911. The most prestigious residential area in the community was in this part of McKee, sometimes called Silk Stocking Row. (Published by W. P. Kirk.)

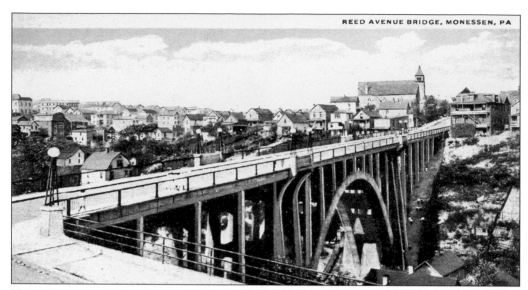

THE VIADUCT. When it was first built by Nicola Construction in 1907, the viaduct that connected Reed Avenue over Third Street was considered an engineering marvel. The first car to cross was Dr. W. D. Hunter's Cadillac. (Published by I. Robbins and Son, Pittsburgh; courtesy of Bill Maurer.)

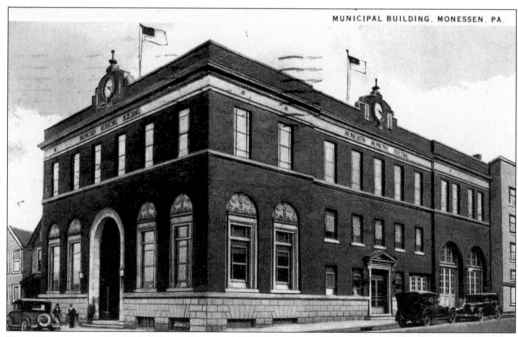

THE MUNICIPAL BUILDING, AT THIRD AND DONNER, 1930. This outstanding red brick and stone building was erected by the Motz Lumber Company in 1927 from the architectural plans of Ernest Clark. In addition to city offices, it contains the police station, the fire station, and the council chambers. (Published by I. Robbins and Son, Pittsburgh.)

THE STAR THEATER, SIXTH STREET, 1910. McShaffey's Star Vaudeville Theatre began with live performances, shifted to silent movies, and finally showed talkies. It was tragically demolished to add a parking lot to the downtown area. The first radio station in the valley (February 21, 1927) was WMBJ, which broadcast from the Star. (Published by Amstead Brothers, Wheeling.)

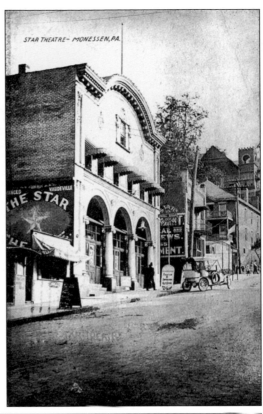

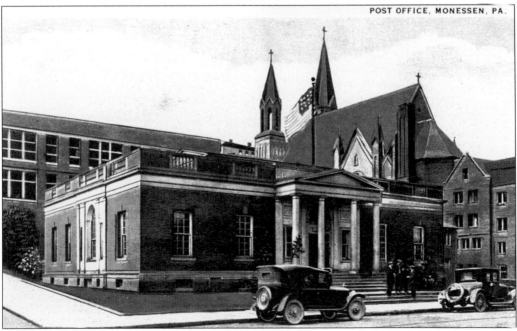

THE POST OFFICE. Monessen's delightful post office was dedicated on February 18, 1919. It served the community well until the 1970s, when a new, nondescript building was erected. Purchased by St. Leonard's, it was torn down for a parking lot *c.* 1966. (Courtesy of Ken Harhai.)

85

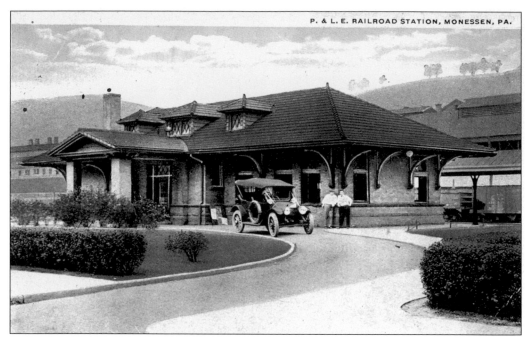

THE RAILROAD STATION, 1918. Erected in 1900, this station saw 5,000 tickets sold in December 1903. Two-thirds of the travel south of Pittsburgh originated in Monessen, and the evening express sold 241 tickets daily. (Published by I. Robbins and Son, Pittsburgh.)

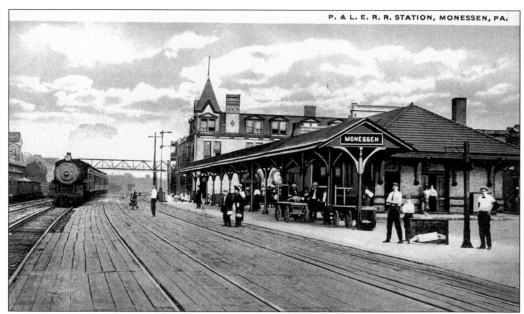

P. & L. E. R. R. STATION, MONESSEN, PA.

A TRACKSIDE VIEW. Originally, the Pennsylvania & Lake Erie tracks ran through the heart of the town, but they were rerouted to the riverside. The Pennsylvania & Lake Erie was called the Little Giant because it accomplished so much on its more than 65 miles of track. (Published by I. Robbins and Son, Pittsburgh.)

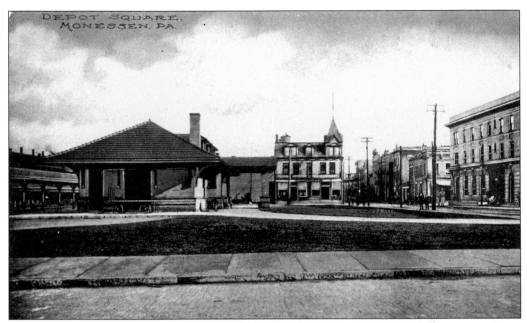

THE DEPOT SQUARE. The only square in Monessen was at the train station. Here, we see the station, on the right the bank building, and in the center the May Hotel. Note the spiral of the hotel is different from the spiral on the previous card.

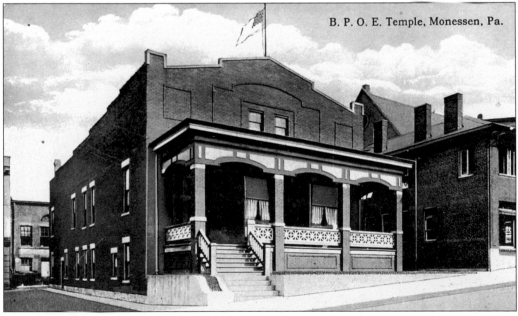

THE ELKS TEMPLE, SEVENTH AND DONNER. The Monessen Lodge No. 773 was chartered on March 20, 1902. It dedicated this temple on November 16, 1914. The structure was built by the Motz Lumber Company of Monessen for a cost of $50,000. The Elks lodge on Seventh Street was used as a hospital during the influenza outbreak. (Published by I. Robbins and Son, Pittsburgh.)

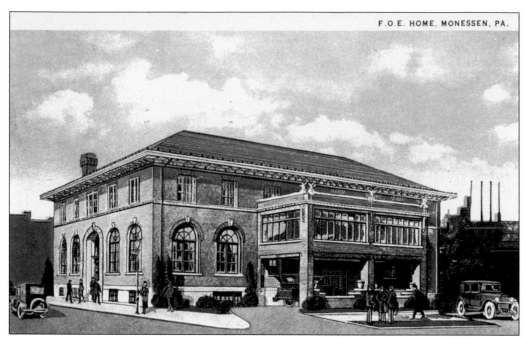

THE FRATERNAL ORDER OF EAGLES HOME, EIGHTH AND DONNER, 1935. Although originally erected for the Eagles, this building is best remembered as the headquarters of the AFL-CIO. It is shown here as it was originally built in the early part of the 20th century. It is still a viable building in Monessen. (Published by I. Robbins and Son, Pittsburgh.)

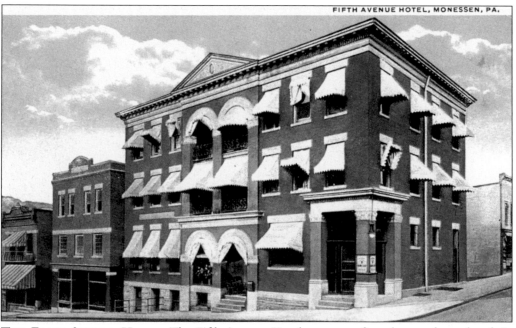

THE FIFTH AVENUE HOTEL. The Fifth Avenue Hotel was one of nearly two dozen hotels in Monessen. Today, it is the only existing hotel building in the city. It is one of Monessen's important treasures. (Published by I. Robbins and Son, Pittsburgh.)

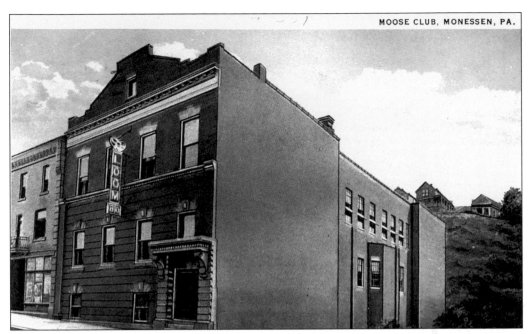

THE MOOSE CLUB, THIRD AND SCHOONMAKER, 1930. Few realize that the structure known for years as a manufacturing plant was originally erected by the Fraternal Order of Moose. Today, it is vacant but remains much as it is seen here. (Published by I. Robbins and Son, Pittsburgh.)

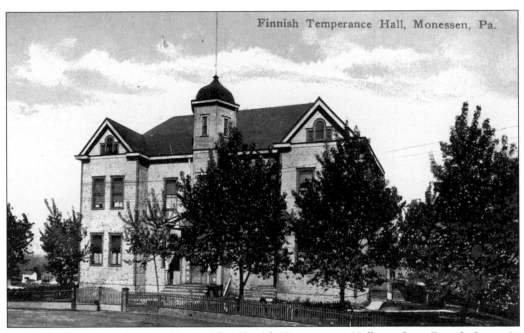

Finnish Temperance Hall, Monessen, Pa.

THE FINNISH TEMPERANCE HALL. The Finnish Temperance Hall stood on Fourth Street in Finntown and was one of two Finnish clubs. It was the home of the world-famous Louhi Band, which practiced on its lawn on Sunday afternoon. It was tragically torn down in 2001.

89

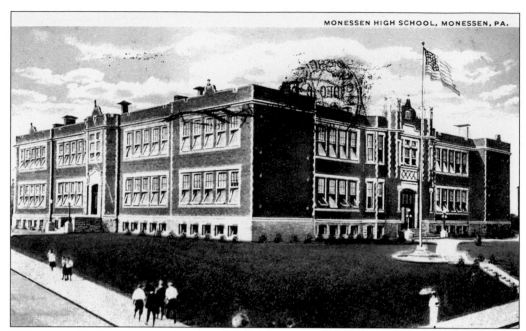

MONESSEN HIGH SCHOOL, 1917. Stretching for an entire city block along Sixth Street, from Reed to Knox Avenues, the Monessen Senior High School was erected in 1915. It burned to the ground in a dramatic fire, the most devastating in the city's history, on April 10, 1946. (Published by I. Robbins and Son, Pittsburgh.)

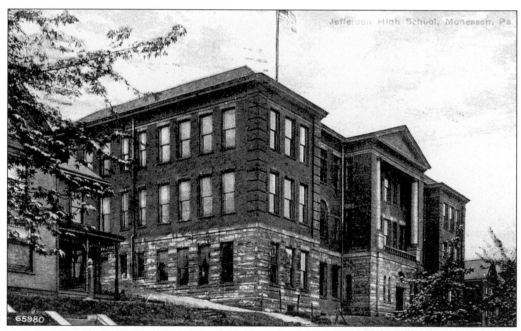

THE JEFFERSON SCHOOL, 1912. The Jefferson School was erected in 1903. It was designed by Marcius Rosseau of Pittsburgh as a 17-room Corinthian building, which was originally to have a cupola on the roof. While it was being built, students attended classes in sheds on the property.

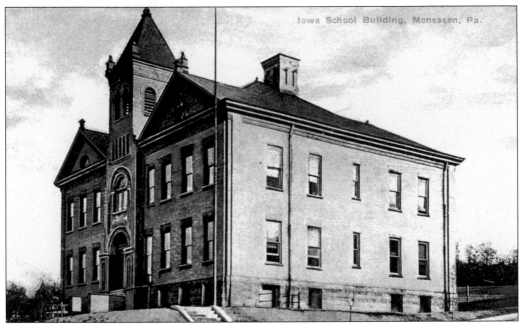

IOWA SCHOOL. Iowa School was built in 1902 on Oneida Street and was the second school built in Monessen. The land for the school was donated to the city by the Manown family. It served as a civic center in the 1950s. The site now houses Eastgate Manor, a senior citizen housing facility.

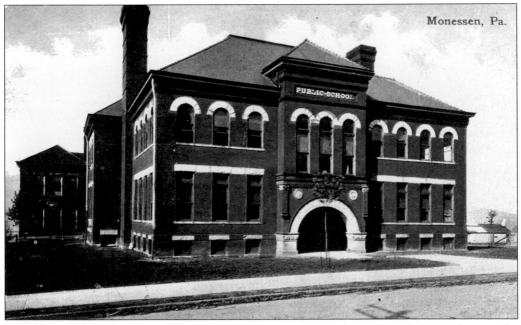

Monessen, Pa.

PUBLIC-SCHOOL

MCKINLEY SCHOOL. Located on Reed Avenue behind the Jefferson School, McKinley was the first school building to be torn down.

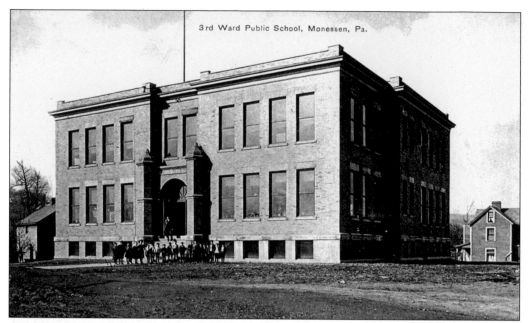

THE THIRD WARD SCHOOL. Better known as the Linden School, this building served the Third Ward in Monessen for many years. It was torn down in recent years. (Published by L. F. Harbaugh, Monessen.)

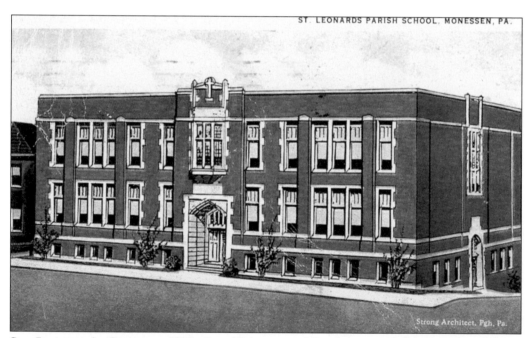

ST. LEONARDS PARISH SCHOOL, MONESSEN, PA.

Strong Architect. Pgh. Pa.

ST. LEONARD'S SCHOOL, 1928. In addition to public elementary schools, Monessen had parochial schools. There was almost one for each Catholic church in the community. This, the largest, was built in 1924. It is still standing. (Published by I. Robbins and Son, Pittsburgh.)

92

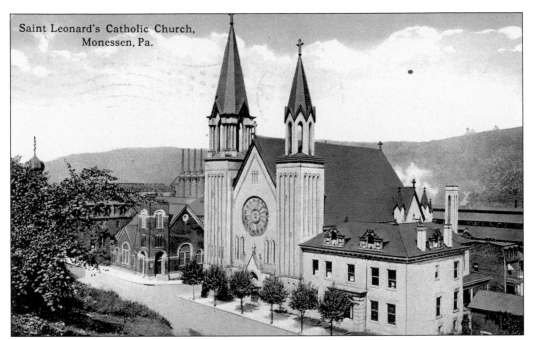

Saint Leonard's Catholic Church,
Monessen, Pa.

ST. LEONARD'S CATHOLIC CHURCH, SEVENTH AND SCHOONMAKER, 1917. St. Leonard's was organized by Rev. Leonard Stenger in November 1901, and this building was erected in 1907. It was the first Catholic church in Monessen. (Published by I. Robbins and Son, Pittsburgh.)

THE FIRST PRESBYTERIAN CHURCH, 1908. Organized in Monessen in 1998, this building on Parkway at Sixth was dedicated on June 20, 1901. By 1925, a new church was built, and this one was torn down. (Manufactured in Belgium.)

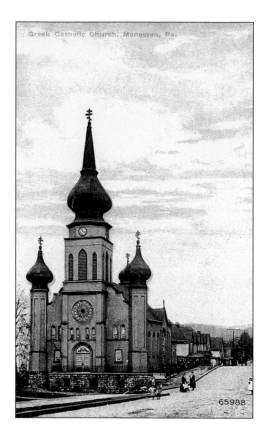

THE GREEK CATHOLIC CHURCH. Shown here is the first Greek Catholic church in Monessen and perhaps the United States. When the Carpatho-Rusyns came to America, they had a faith without a formal church. The battle for their allegiance was played out among the congregations of the Mon Valley. They won the right to be independent.

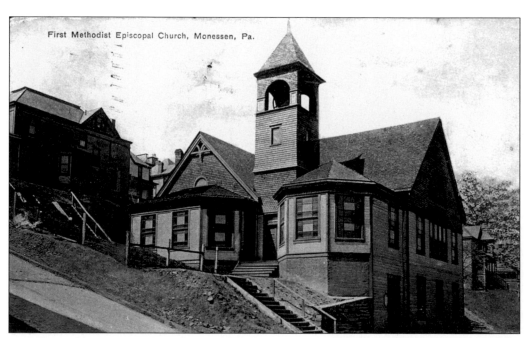

THE FIRST METHODIST EPISCOPAL, 1911. Organized in 1898, the congregation dedicated this wooden building on February 4, 1900. (Published by L. F. Harbaugh.)

THE FIRST METHODIST EPISCOPAL. They built this stone church at the same location of Fourth and Schoonmaker in 1930. It still stands.

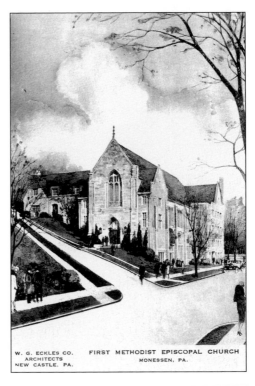

W. G. ECKLES CO.
ARCHITECTS
NEW CASTLE, PA.

FIRST METHODIST EPISCOPAL CHURCH
MONESSEN, PA.

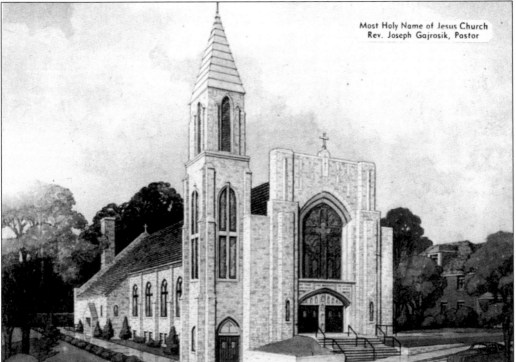

Most Holy Name of Jesus Church
Rev. Joseph Gajrosik, Pastor

THE MOST HOLY NAME OF JESUS CHURCH. The first wooden church was erected on Reed Avenue in 1903. This church was built in the 1950s.

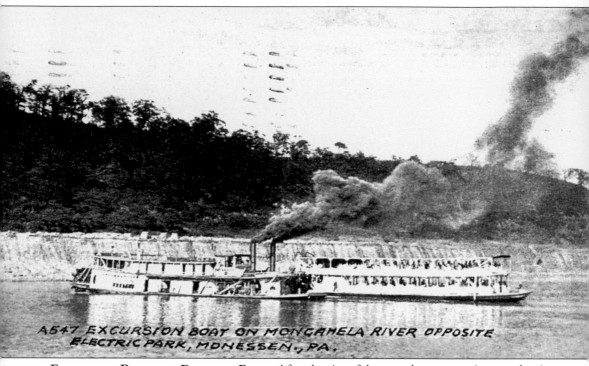

EXCURSION BOATS AT ELECTRIC PARK. After the rise of the steamboat, excursions on the river became very popular. Mark Twain took such a boat when he toured the Monongahela in 1891. These excursion boats are near Electric Park in Monessen. (Courtesy of Bill Maurer.)

Six

DONORA AND WEBSTER

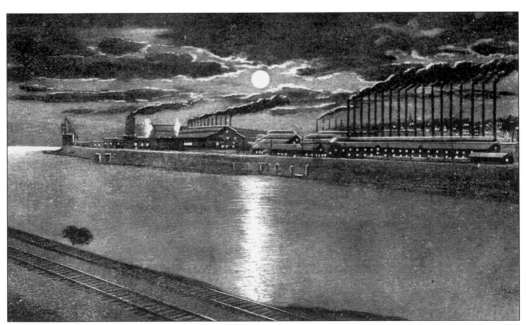

A NIGHT SCENE. The factories of the valley often looked beautiful at night with the strong contrasts of light and dark. This is the American Steel and Wire Company plant. (Published by I. Robbins and Son, Pittsburgh; courtesy of Glen Howis.)

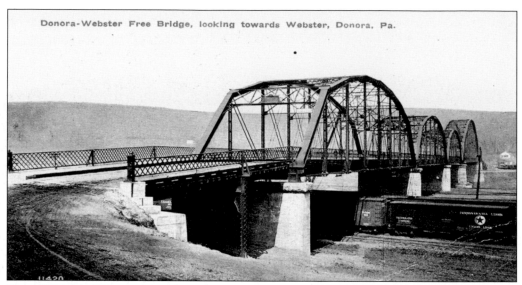

THE DONORA-WEBSTER BRIDGE. On December 4, 1908, this bridge replaced the growing number of ferries that crossed the river at this point. It was built because the Carnegie mills in Monessen and Donora needed an easy way to share supplies and have access to railways on both sides of the river. (Courtesy of Glen Howis.)

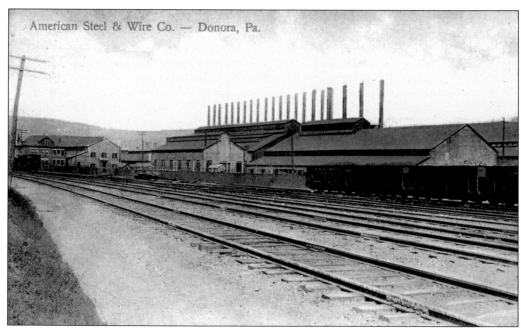

THE AMERICAN STEEL AND WIRE COMPANY. The American Steel and Wire Company began as the Union Steel Company in 1899. It was purchased by R. B. Mellon and the U.S. Steel Corporation and called the Donora Steel and Wire Works. The mill ran for 300 waterfront acres. (Published by Donora Pharmacy.)

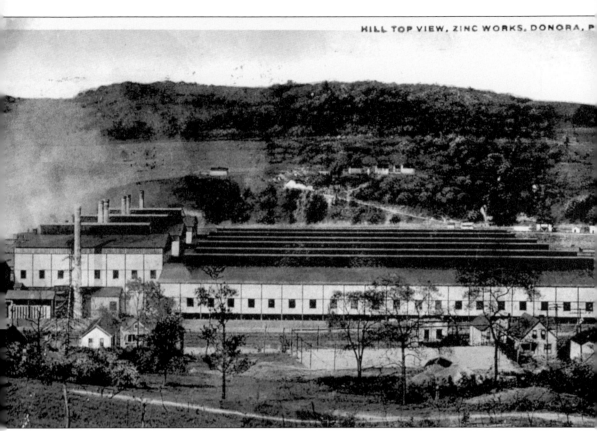

THE ZINC WORKS. The zinc works of the American Steel and Wire Company was built in 1915 and became the largest in the world. It occupied 45 acres of riverfront property. Unfortunately, one of the by-products of zinc is sulfuric acid. That helped to create the first environmental air disaster ever recorded in the United States. The fumes from the mill combined with an air inversion that lingered over the community and valley for days. The city went black. The air was deadly. It killed 20 people while thousands throughout the valley were sickened with respiratory problems. Because of this disaster, the Clean Air Act of 1970 was eventually enacted. (Published by I. Robbins and Son, Pittsburgh.)

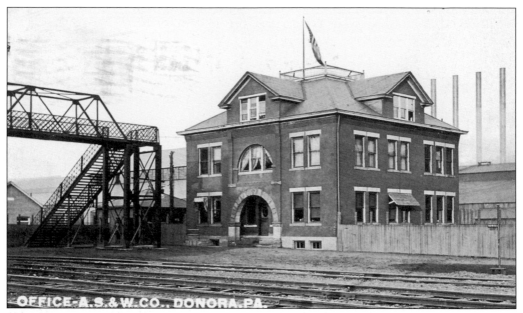

THE OFFICE OF THE AMERICAN STEEL AND WIRE COMPANY. This building housed the general superintendent's office; the production, planning, and billing departments; and the mill's engineers. (Courtesy of Glen Howis.)

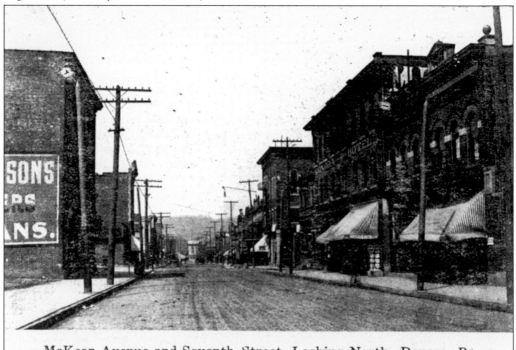

McKean Avenue and Seventh Street, Looking North, Donora, Pa.

MCKEAN AVENUE AND SEVENTH STREET, LOOKING NORTH. The main street of Donora bears the same name as Charleroi's. The community was laid out by the Union Improvement Company in 1900 and was incorporated on February 11, 1901.

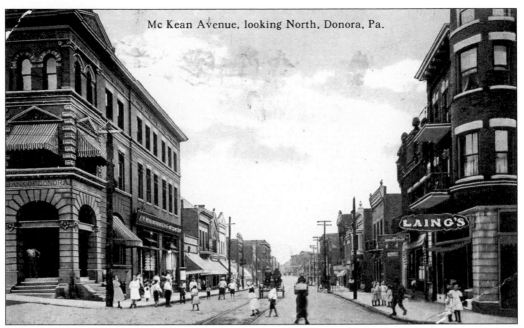

MCKEAN AVENUE, LOOKING NORTH. The First National Bank is on the left in this image. (Courtesy of Glen Howis.)

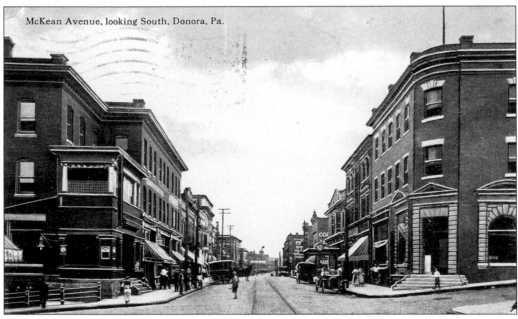

MCKEAN AVENUE, LOOKING SOUTH. In 1769, Donora was called Horseshoe Bottom, probably because of the bend in the river. (Courtesy of Glen Howis.)

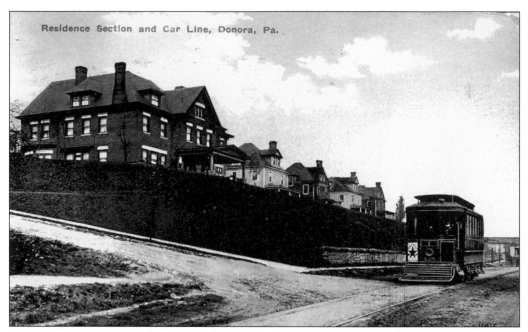

THE TERRACE AND A STREETCAR. Horse-drawn trolley cars began moving in Donora on Saturday, December 22, 1906. That first car, No. 429, was called Maude. In this scene, the car is passing the mill superintendent's mansion, a Colonial Revival building that is now the Donora Spanish Club.

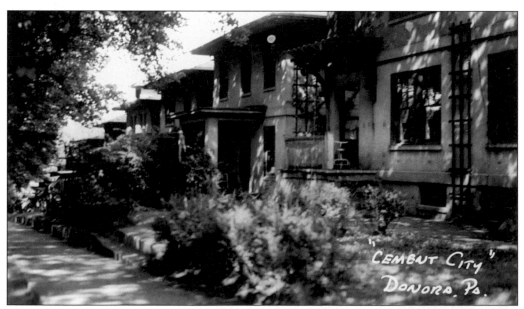

Cement City
Donora, Pa.

CEMENT CITY, 1951. This unusual tree-lined community covers 88 acres and contains 80 buildings. It was constructed by U.S. Steel for its middle management families and was used from 1900 to 1924. The Prairie School, single-family structures were constructed by Lambie Concrete Housing Corporation and are made entirely of concrete.

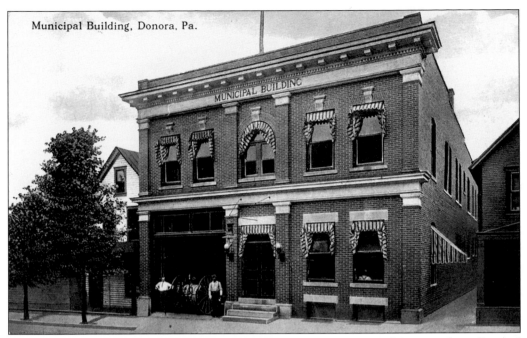

Municipal Building, Donora, Pa.

THE MUNICIPAL BUILDING, 1915. As with most municipal buildings of the time, the police and fire departments were located here. There was also a firing range.

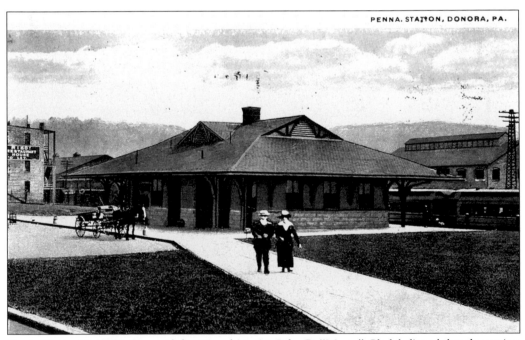

PENNA. STATION, DONORA, PA.

PENN STATION, 1912. Donora's longtime historian John P. "Moon" Clark believed that the station at Donora "had the biggest business of any station on the Monongahela Division, aside from the Southside, Pittsburgh station." It employed 19 men. (Published by I. Robbins and Son, Pittsburgh.)

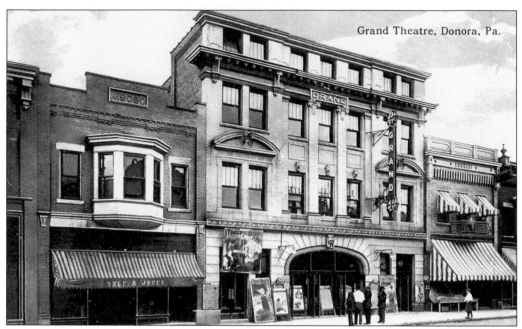

Grand Theatre, Donora, Pa.

THE GRAND THEATER, 1914. The Grand (later called the Harris) thrilled Donorians with its features. For many years, high school commencements were held here too.

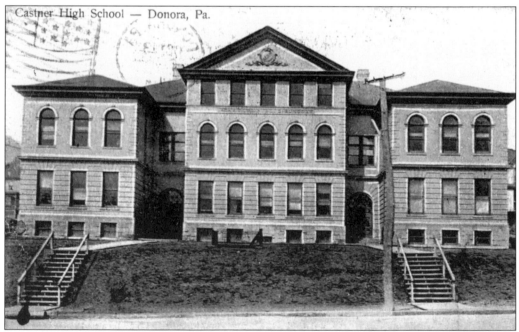

Castner High School — Donora, Pa.

CASTNER HIGH SCHOOL, 1914. Named for Peter Castner, the German immigrant who settled here in 1775, Castner High School opened in 1903. It had 12 rooms and an auditorium. The first graduating class was in 1904. The very first school in Donora was the Allen School, built in 1900. (Published by Donora Pharmacy.)

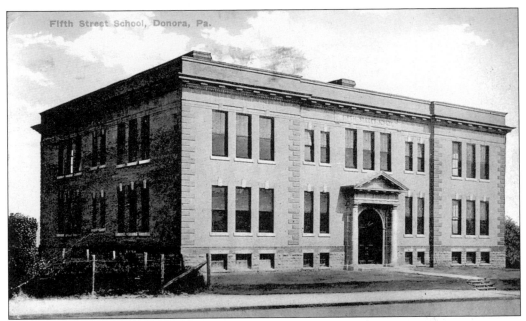

THE FIFTH STREET SCHOOL, 1915. This school, which is still standing, opened its doors in 1909.

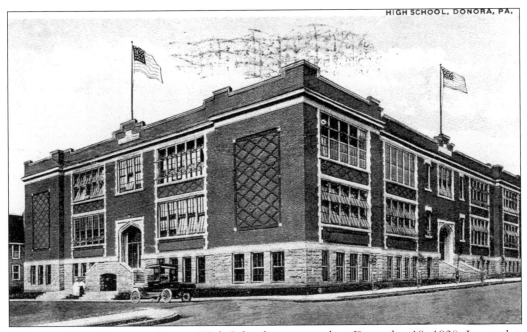

DONORA HIGH SCHOOL. Donora High School was opened on December 19, 1930. Located at Waddell Avenue, it is now the Donora Elementary School. (Published by I. Robbins and Son, Pittsburgh; courtesy of Glen Howis.)

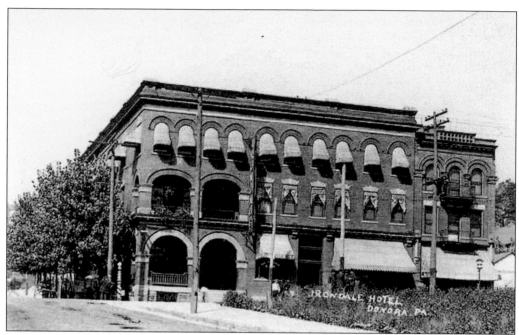

THE IRONDALE HOTEL. Located at MeKean and Sixth, this is the first hotel in Donora. It was originally owned by C. F. Cardon and then by Nat Harris and Clarence L. Egbert. The barbershop was frequented by the bosses in the mill. Other hotels included the Donora, McManus, Indiana, and Columbia. (Courtesy of Glen Howis.)

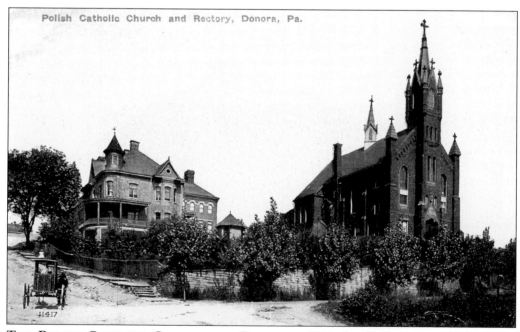

Polish Catholic Church and Rectory, Donora, Pa.

THE POLISH CATHOLIC CHURCH AND RECTORY, 1913. In all, there were 22 houses of worship in Donora. As in the other valley towns, each ethnic group had its own church. (Courtesy of Glen Howis.)

THE METHODIST EPISCOPAL CHURCH AND LUTHERAN CHURCH. Donora had a number of churches, and many of them were located in the same area. It was a traffic jam every Sunday as people went to worship. (Courtesy of Glen Howis.)

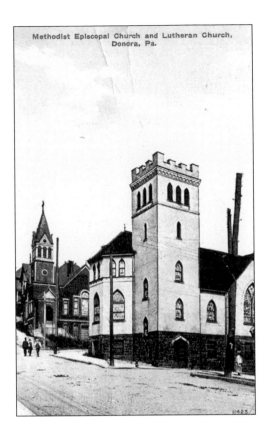

Methodist Episcopal Church and Lutheran Church, Donora, Pa.

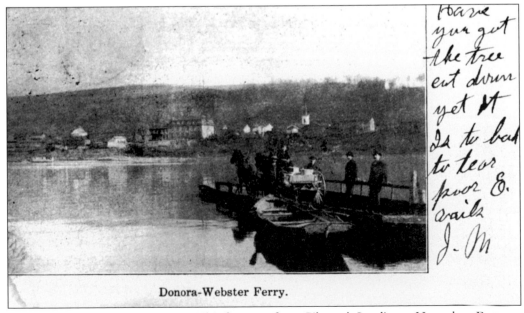

Donora-Webster Ferry.

THE WEBSTER–DONORA FERRY. This ferry ran from Gilmore's Landing at Horseshoe Bottom, now Donora, to Webster. In return from Donora came the Castner ferry in 1788 and the Dobb's and Brown's ferries later on.

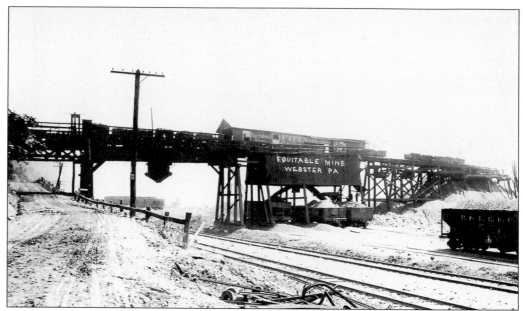

EQUITABLE MINE. The first mine in Webster was opened in 1859 by Jacob Tomer and John Gilmore. John Gilmore owned most of the coal rights in the area. He built a line of steamboats and barges to service his coal mines, which were known as the Gilmore Line. (Published by Downham Photographer, McDonald; courtesy of Glen Howis.)

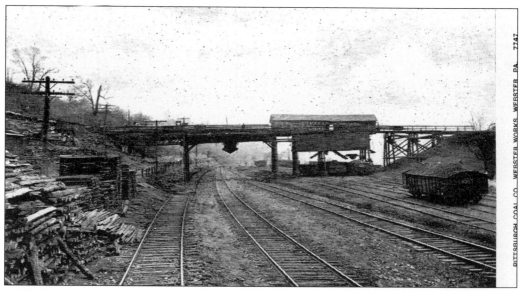

A PITTSBURGH COAL COMPANY TIPPLE. Here is an excellent view of the railroad side of a coal tipple. (Courtesy of Bill Maurer.)

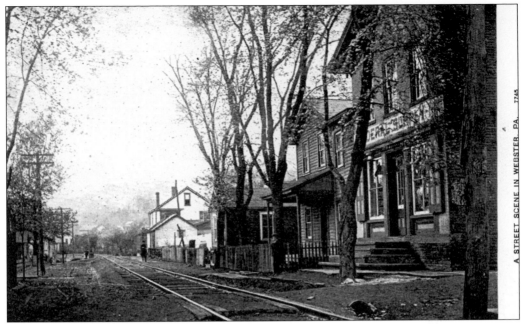

MAIN STREET IN WEBSTER. When Webster thrived, it had three hotels. The Pennsylvania & Lake Erie then put its tracks down on the main street of town. Things began to change. Today, Route 906, a two-lane highway, runs through the main street. (Published by George V. Millar and Company, Scranton; courtesy of Glen Howis.)

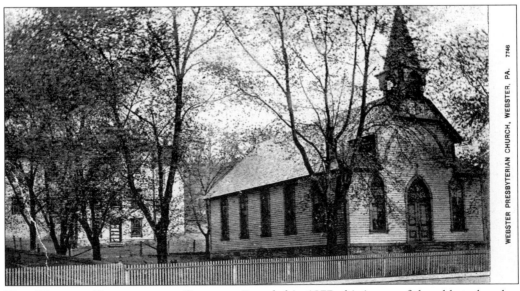

THE WEBSTER PRESBYTERIAN CHURCH. Founded in 1877, this is one of the oldest churches in the valley. (Published by George V. Millar and Company, Scranton; courtesy of Bill Maurer.)

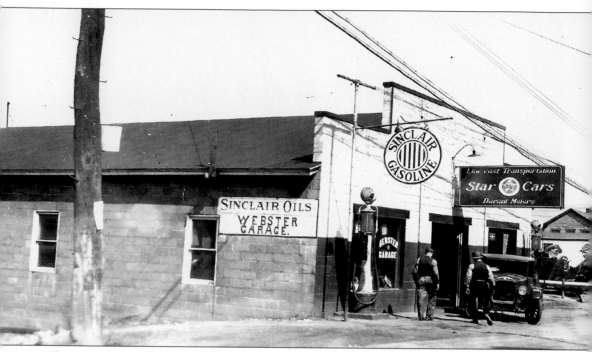

THE WEBSTER GARAGE. This garage, still standing, was operated by Walter Greenwood *c.* 1928. He was selling Star automobiles. Prior to his ownership, the dealership was owned by Cal Layton, who sold Briscoe cars. (Courtesy of Bill Maurer.)

Seven

MONONGAHELA

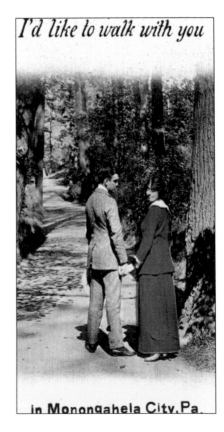

WALKING IN MONONGAHELA. Monongahela began as Parkison's Ferry *c.* 1796. On April 8, 1833, it was incorporated as the borough of Williamsport, while the post office remained Parkison's Ferry. The post office and the town officially became part of Monongahela City on April 1, 1837. On March 24, 1873, it became a third-class city and was simply known as Monongahela. Locals still call it Mon City. (Published by Holmfrith Bamforth and Company, England.)

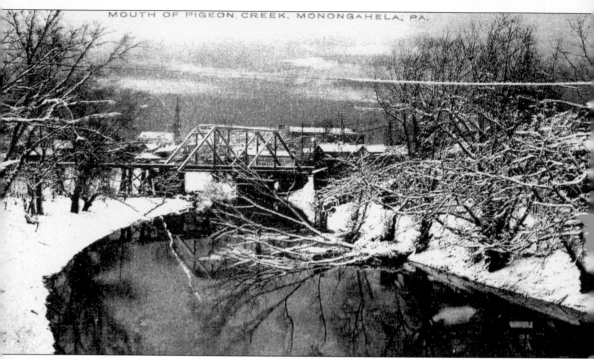

PIGEON CREEK. Modern settlements began as two ferries were licensed at Pigeon Creek in 1769: Parkinson's and Devore's. Those ferries and that landing flourished. Nearby, at what became known as Whiskey Point, the 200 men representing four counties met on August 14, 1794, to protest and establish a plan of action against the excise tax on whiskey. It was part of the Whiskey Rebellion. Pigeon Creek was also the home of the early boatbuilding industry in Monongahela. Early boats of American Indian traders would take furs downriver to New Orleans. (Published by Union News Company, New York, New York, and Pittsburgh; courtesy of MAHS.)

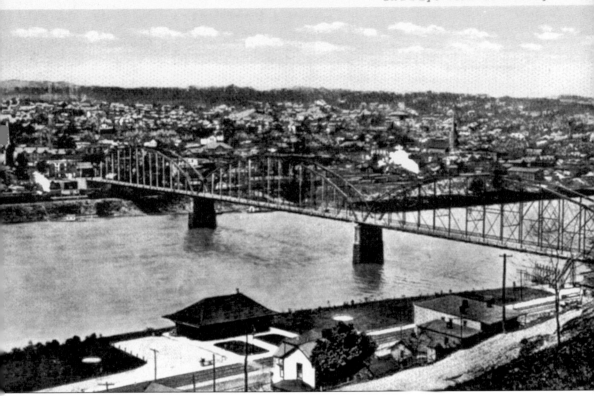

A BIRD'S-EYE VIEW, 1940. As the city grew, it required yet another bridge, and this three-span metal-truss bridge was constructed in 1910. The engineer was W. P. Rothrock for the Fort Pitt Bridge Works. The bridge was replaced in 1988 by PennDot. (Published by C. T. American Art, Chicago.)

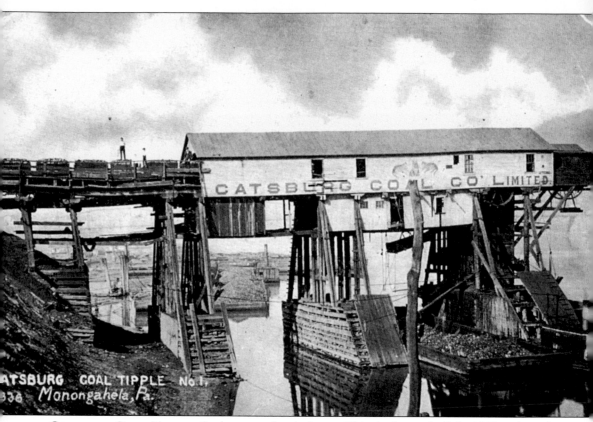

CATSBURG COAL TIPPLE No. 1.
338 Monongahela, Pa.

CATSBURG COAL TIPPLE. Coal was another industry. This tipple was built in 1860 and run by Catsburg Coal south of Pigeon Creek from 1892 to 1903, when it was purchased by the Consolidated. The tipple and the coal patch around it were allegedly called Catsburg after a woman and her daughter who fought like cats. (Courtesy of John Neill.)

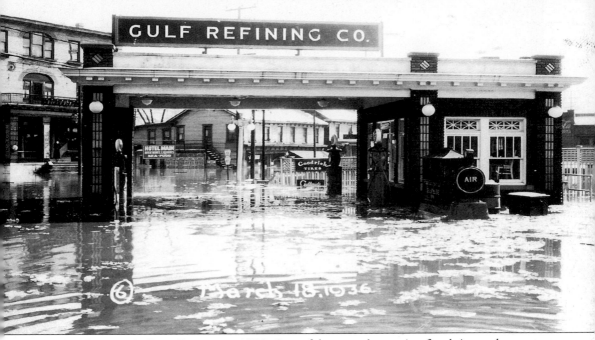

THE ST. PATRICK'S DAY FLOOD OF 1936. One of the most devastating floods in southwestern Pennsylvania struck on March 17, 1936. Monongahela, like all the river communities, was inundated. Other serious floods occurred on July 11, 1881, and March 14, 1907. (Courtesy of MAHS.)

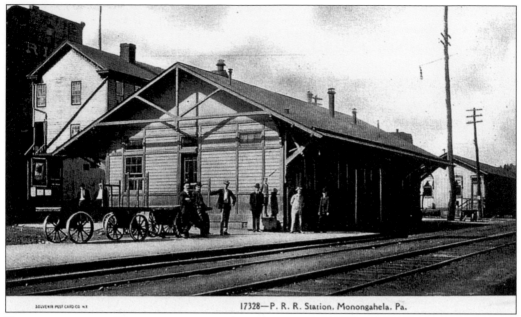

17328—P. R. R. Station. Monongahela. Pa.

PENNSY ON THE WEST SHORE. As the Pennsy approached the Mid Mon Valley from Pittsburgh, it was forced in 1873 to stop in Monongahela because of economics. Although the stop was a delay, it did not prevent the railroad from continuing around the valley. In 1924, between 20 and 21 passenger trains ran through Monongahela daily.

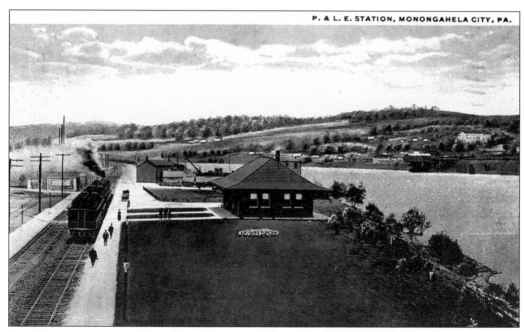

P. & L. E. STATION, MONONGAHELA CITY, PA.

THE PENNSYLVANIA & LAKE ERIE STATION. The railroad arrived on the east bank of the river across from Monongahela in 1889. That gave the community access to both railways. (Published by I. Robbins and Son, Pittsburgh.)

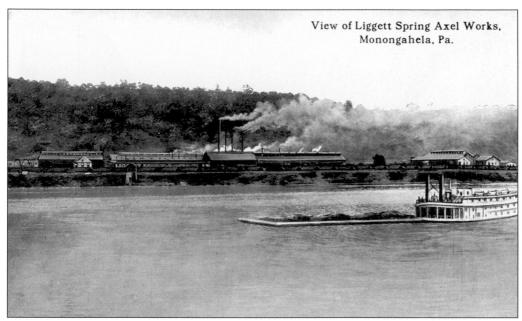

View of Liggett Spring Axel Works, Monongahela, Pa.

LIGGETT SPRING AND AXLE WORKS. Obviously, this company, which was founded in 1862, made axles. One of its customers was the federal government, who ordered axles for the Jeeps of World War II. The company shut down in 1980s. (Published by I. Robbins and Son, Pittsburgh.)

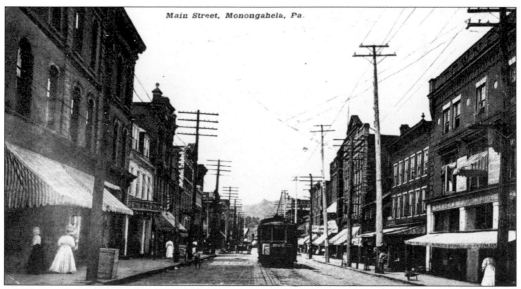

Main Street, Monongahela, Pa.

MAIN STREET, 1910. There is only one shopping street in Monongahela: Main Street. Unlike other avenues in the valley, it was laid out at 60 feet wide. That is because it originally had an open-air farmer's market where local farmers would bring their wares several times a week. It became known as Market Street. (Published by Monongahela Pharmacy; courtesy of MAHS.)

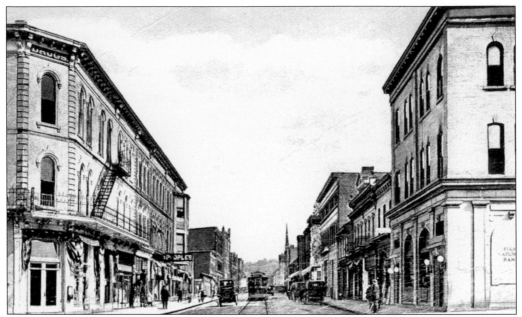

MAIN STREET, LOOKING SOUTH. The original lots along Main Street were different from other valley towns too. They were 60 by 200 feet large, allowing for a spacious front and an entrance and windows at both the front and back of the store. (Courtesy of MAHS.)

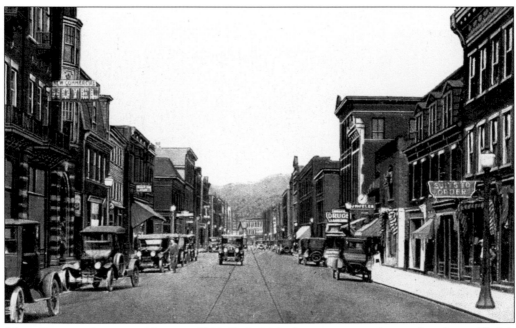

MAIN STREET, LOOKING NORTH, 1928. Early Main Street was sometimes referred to as Glade's Road, because it was a continuation of the road from Bedford to West Newton and across the river to Monongahela. (Published by I. Robbins and Son, Pittsburgh; courtesy of MAHS.)

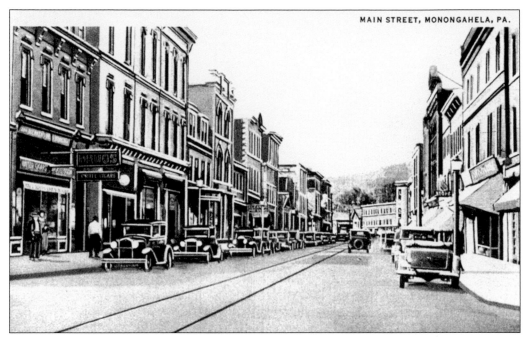

MAIN STREET, THE 1930S. The original street was made of brick, and it was not to difficult to place the tracks for the trolley cars. They remained long after the trolleys were retired.

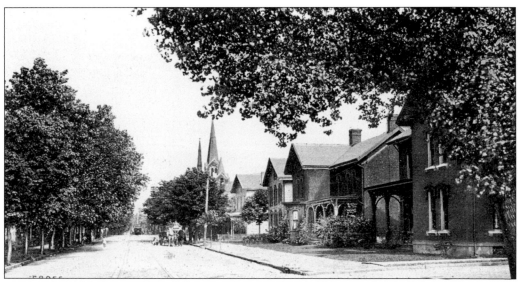

MAIN STREET RESIDENTIAL, 1914. Around Chess Park, Main Street was residential. The old Victorian homes still stand, and many of them have been converted to small office buildings and antique shops. (Courtesy of MAHS.)

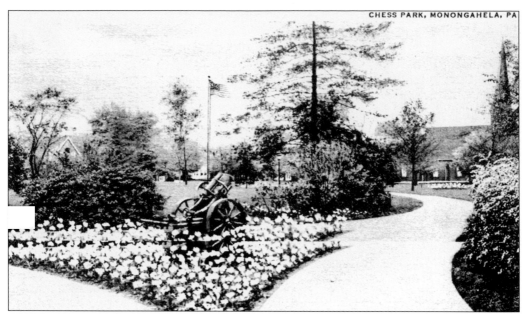

CHESS PARK. Chess Park is named for Mary Wickerham Chess, whose home was on the property. In fact, she owned 149 acres from Third Street to New Eagle. Mary donated Chess Park to the community. (Courtesy of MAHS.)

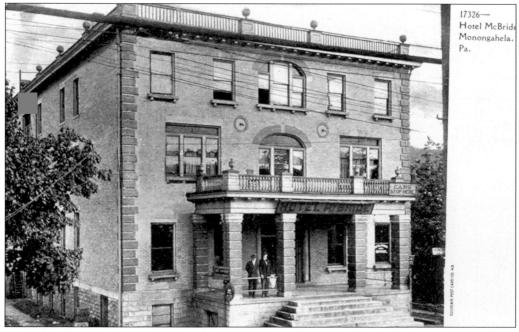

17326—
Hotel McBride
Monongahela.
Pa.

THE HOTEL McBRIDE, 1911. The first hotels in Monongahela were inns and taverns along the road to Washington. The City Hotel replaced one of these taverns to be the first true hotel in the community. The McBride came sometime later.

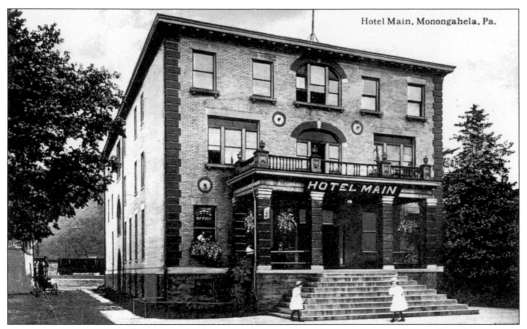

THE HOTEL MAIN. The McBride became the Main in the 1890s. It is located on East Main Street, and its proprietor was A. L. Dievart. In an advertisement, Dievart claimed that the Hotel Main was "the largest rathskellar in the valley. All street cars stop at the door." (Published by I. Robbins and Son, Pittsburgh.)

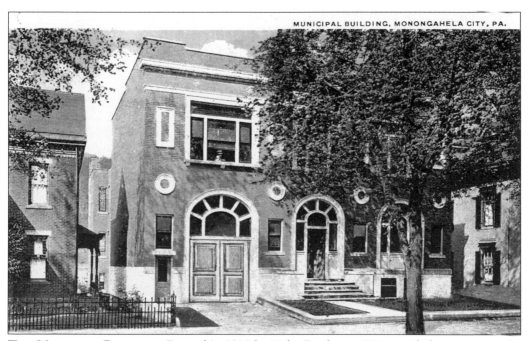

THE MUNICIPAL BUILDING. Erected in 1915 by Yohe Brothers, a Monongahela contractor, the building was designed by Conrad C. Compton of Donora. It currently houses the ambulance service. (Published by I. Robbins and Son, Pittsburgh.)

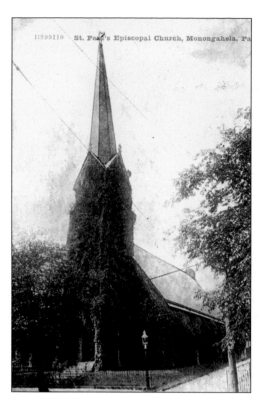

ST. PAUL'S EPISCOPAL CHURCH, 1910.
This building was erected at 127 Main Street in 1866. Other early churches in Monongahela were the African Methodist Episcopal (1834), the Methodist Episcopal, the Baptist (*c.* 1860), and the First Presbyterian (*c.* 1815). (Published by H. G. Zimmerman and Company, Chicago, Illinois.)

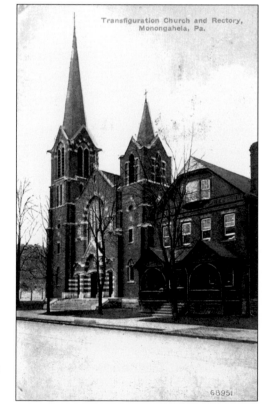

THE TRANSFIGURATION CHURCH, 1912.
The first Transfiguration Church was built in 1865 at 722 West Main. Catholics were celebrating mass in Monongahela as early as 1816. Their first church in the community was built in 1865. A new church was erected in 1906.

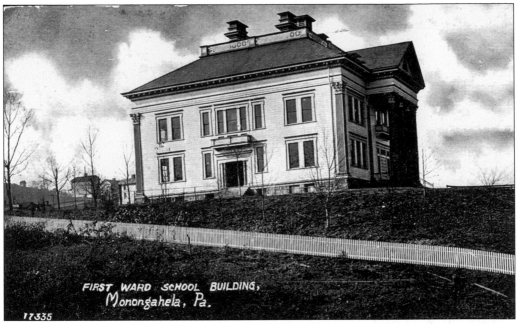

THE FIRST WARD SCHOOL, 1907. Early education in the community took place in log cabins. Later, private homes were used. The first organized school in Monongahela and Washington County was the Union School, which burned a few years later. This school was erected in 1896.

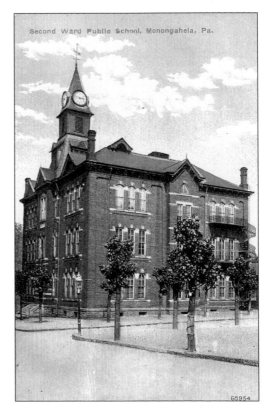

THE SECOND WARD SCHOOL, 1911. The custodian of this school, John J. Neill, made his son John A. Neill wind the steeple clock, which had been made in Germany, every Wednesday and Saturday. The weights ran down to the first floor, and it was a big chore. (Courtesy of John Neill.)

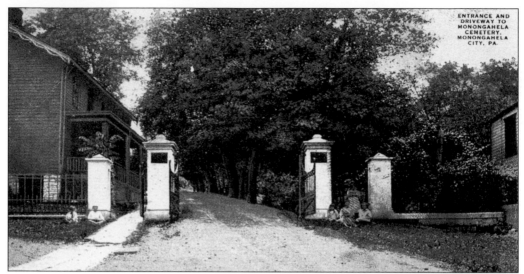

THE ENTRANCE TO MONONGAHELA CEMETERY, 1917. Monongahela Cemetery received its charter in 1863, making it one of the oldest cemeteries in the Mid Mon Valley. It was designed by the famous firm of Hare and Hare. No longer standing is the superintendent's home, seen here on the left. (Courtesy of MAHS.)

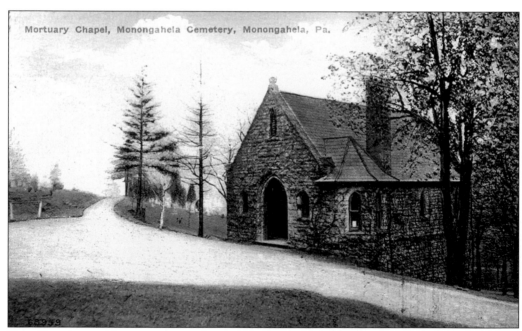

Mortuary Chapel, Monongahela Cemetery, Monongahela, Pa.

THE CHAPEL AT MONONGAHELA CEMETERY, 1911. The chapel, still in use today, was erected in 1892 from a design created by architect Frank Keller.

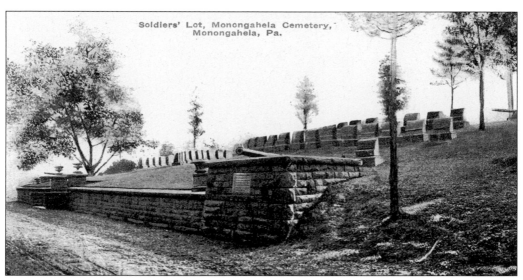

SOLDIER'S LOT, 1911. Various sections of the cemetery have been set aside for war veterans. This is the Grand Army of the Republic plot, complete with government-issued tombstones. The last Civil War soldier was interred here in the 1930s. (Courtesy of MAHS.)

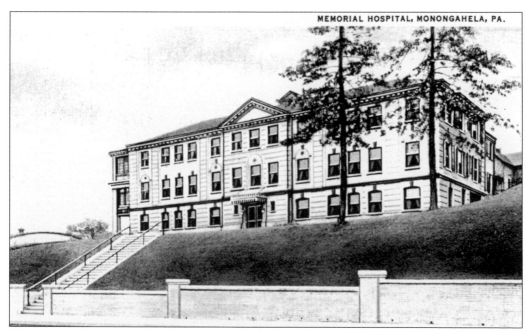

MEMORIAL HOSPITAL. The first Monongahela hospital was erected in memory of Civil War veterans in 1902. A new facility was created in 1913, and additional wings were added in 1953.

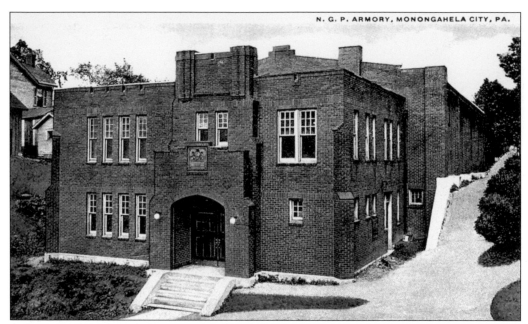

THE NATIONAL GUARD ARMORY. Prior to World War II, several communities in the valley had their own National Guard units. The men would meet every weekend for maneuvers and in the summer go to boot camp for several weeks. These units no longer exist in the valley. (Published by I. Robbins and Son, Pittsburgh.)

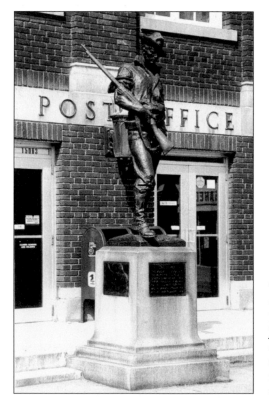

THE POST OFFICE AND THE HIKER. This Classical Revival post office was erected at Fourth and Chess in 1917. The architect was James A. Wetmore. The statue was dedicated on August 15, 1915, in memory of soldiers, sailors, and Marines who fought against Spain, in the Philippine Insurrection, and in the campaign in China. (Courtesy of John Neill.)

126

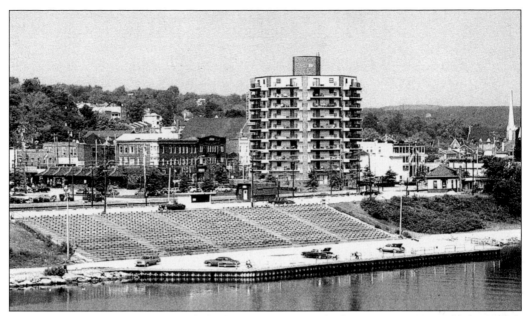

ALONG THE RIVER. Monongahela Aquatorium was built to commemorate the 200th anniversary of Monongahela. Constructed by Frank Irey Jr., it is used for everything from swimming and fishing to rock concerts. (Courtesy of John Neill.)

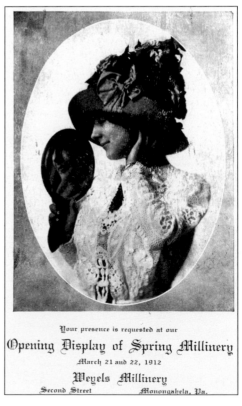

Your presence is requested at our
Opening Display of Spring Millinery
March 21 and 22, 1912
Meyels Millinery
Second Street Monongahela, Pa.

MEYELS MILLINERY, 1912. From the French and Indian War to the heyday of the steel industry, the Mid Mon Valley thrived for over 100 years. It had hundreds of merchants, such as Meyel's, and thousands of employees in its stores, factories, schools, and private industries. The river, the towns, and the people helped make America.

127

BIBLIOGRAPHY

Carlisle, Ronald C. *The Influence of the Monongahela River Navigation System on the Development of the Coal, Coke, Iron, and Steel Industries of the Monongahela River Valley.* U.S. Army Corps of Engineers, 2001.

———. *The Monongahela River Navigation System and Riverside Communities.* U.S. Army Corps of Engineers, 2001.

Clark, John P. "Moon." *The Donora Story.* 1951.

Forrest, Earle L. *The History of Washington County.* 1926.

Kudlik, John J. *1998 Mon River Navigation System NRHP Inventory Project.* USACOE, 1998.

McCall, Edith. *Conquering the Rivers.* Baton Rouge: University of Louisiana, 1984.

Van Voorhis, John. *The Old and New Monongahela.* Higginson Book Company, 1992.

Vivian, Cassandra. *The National Road in Pennsylvania.* Charleston, South Carolina: Arcadia Publishing, 2003.

———. *Monessen: A Typical Steel Country Town.* Charleston, South Carolina: Arcadia Publishing, 2002.

———. *A Walking and Driving Tour of Historic Brownsville.* Brownsville, Pennsylvania: BARC, 1994.

Way, Frederick Jr. *Way's Packet Directory 1848–1994.* Athens: Ohio University Press, 1994.